Fairy World
Coloring Pages

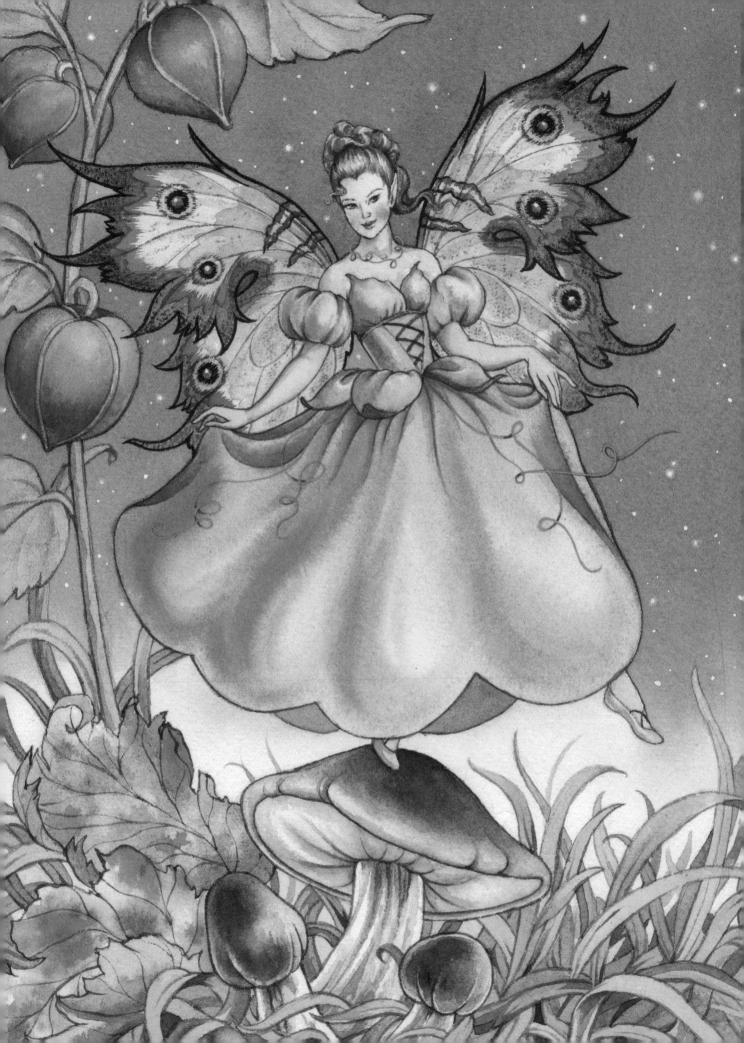

Fairy World
Coloring Pages

Beautiful, Magical, Mystical Fairies to Color

Barbara Lanza

NORTH LIGHT BOOKS
CINCINNATI, OHIO
www.artistsnetwork.com

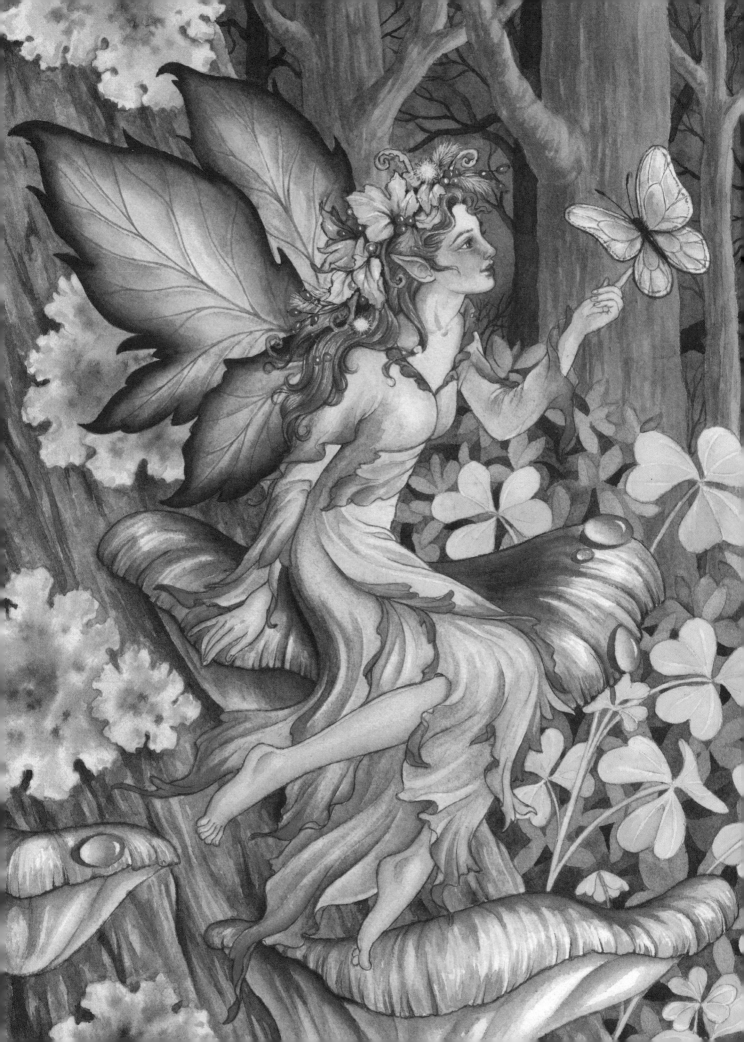

Contents

Color

Learning about color is a lifelong pursuit. Here are some basic facts to get you on your way or to refresh your memory:

Hue is another name for color.

Tint is a color to which white has been added. If you're working in watercolor, you can also add more water to the pigment to lighten it.

Shade is a color to which black or gray has been added.

Key color is the dominant color in a picture.

Neutral gray is a mixture of black and white.

Chroma is the brightness or dullness of a color.

Value is the lightness or darkness of a color.

Temperature is the warmness or coolness of a color.

Understanding these basics will help you decide which colors are best suited to the type of fairy you wish to portray. For instance, a quiet, peaceful fairy would wear and be surrounded by serene colors such as cool violets, blues and greens. An assertive fairy would wear and be surrounded by aggressive, passionate colors such as yellows, oranges and reds.

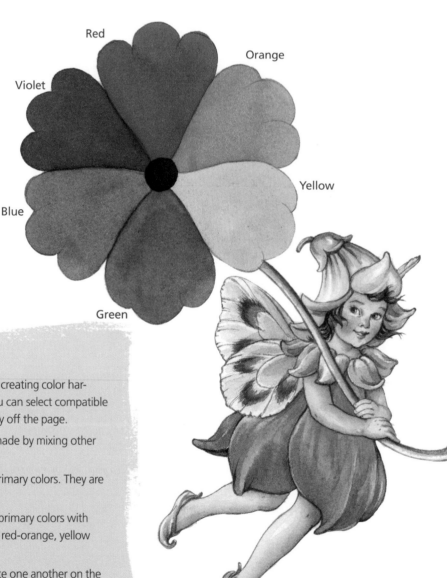

The Color Wheel and Color Harmony

The color wheel is a wonderful visual tool for creating color harmony. By just glancing at the color wheel, you can select compatible color schemes that make your fairies nearly fly off the page.

- *Primary colors* are those that cannot be made by mixing other colors. They are yellow, red and blue.
- *Secondary colors* are created by mixing primary colors. They are orange, green and violet.
- *Tertiary colors* are those made by mixing primary colors with secondary colors. Red and orange become red-orange, yellow and orange become yellow-orange.
- *Complementary colors* are colors opposite one another on the color wheel. Red and green are complements, as are blue and orange and yellow and violet.

Marker Strokes

Marker strokes flow more freely with practice. Flex your wrist and lighten your touch for a line that varies in width. Any scrap paper, such as newspapers and paper bags, will do for this exercise.

1 Draw a Fine Line
Here, a marker with a pointed nib at one end and a wedge-shaped nib at the other end is used. Holding the marker upright and applying little pressure, draw strokes beginning at the bottom and arching up. For lefties like me, you'd begin at the lower right and end at the upper left. For righties, you'd begin at the bottom left and end at the upper right.

2 Make Wider Strokes
For a wider stroke, hold the marker with the pointed nib end on an angle and apply a little more pressure.

3 Create Uneven Edges
Holding the marker with the wedge-shaped end upright and applying more pressure, draw a line from the bottom ending upward. This will result in wider lines with uneven edges.

4 Apply More Pressure
Last, hold the same marker at an angle and apply more pressure in the same manner for lines of the widest width.

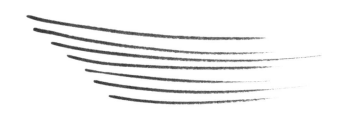

Blending Color Over Color

Pastels are used in this demonstration, but the same method will work for markers, colored pencils and crayons.

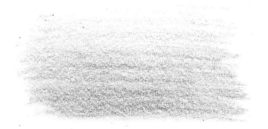

1 Apply the First Layer
Begin by using the side of your pastel to apply an even hue.

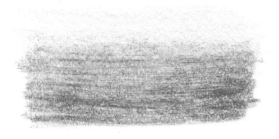

2 Add a Medium Hue
Lay a medium hue over the bottom of the first hue, extending it beyond the first color.

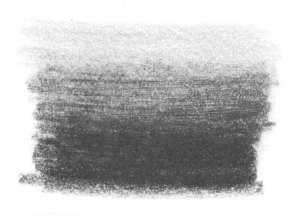

3 Add a Third Color
Apply a medium dark hue over the bottom of the second hue, extending it beyond the second color.

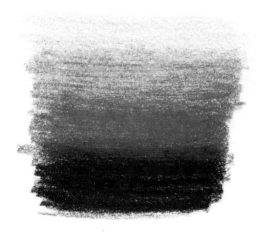

4 Finish
Add a dark hue over the bottom of the third hue, extending it beyond the final color.

Dramatic Effects

Using cheery shades of yellow and orange crayons, pencils or pastels, apply orange or a darker hue over yellow.

 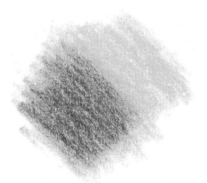 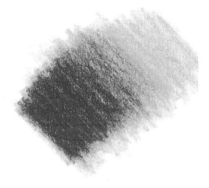

1 Apply Color
Holding your pencil at a 45-degree angle, use medium pressure to apply color.

2 Add a Second Color
Apply a medium shade of orange one-third down the yellow.

3 Finish
Apply medium red to the remaining bottom third. To blend these colors further, you can lightly apply yellow over all of the color.

Pointillism

Pointillism defines texture and adds interest. Try it on part or all of a picture. You can apply an overall hue first before applying the dots.

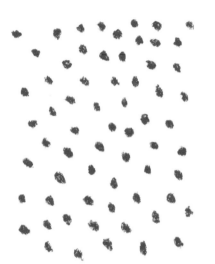

1 Apply the First Layer of Dots
Holding your pastel, crayon, marker or colored pencil perpendicular to the paper, stipple dots in an uneven pattern, leaving enough space in between for adding other colors.

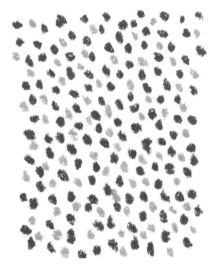

2 Add a Second Color
The colors you choose may differ in hue and value. In the same manner, add a second color.

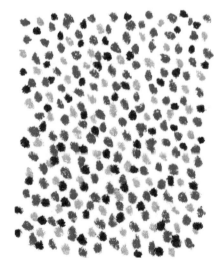

3 Lay Down a Third Color
Repeat with a third color. For the best effect, keep your colors from touching.

4 Finish
Add a fourth color to finish.

Crosshatching

Below are two different crosshatching techniques. Notice how curving the lines in the second technique changes the sense of movement. Bringing the lines closer together creates more density.

STRAIGHT-LINE CROSSHATCHING

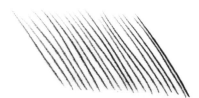

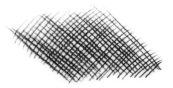

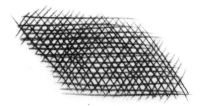

1 Start With Angled Lines
Starting at the bottom, draw your lines at an angle, keeping all lines an equal distance from each other.

2 Add Oppositional Lines
Starting at the opposite side, draw your lines at an angle.

3 Finish
Starting at the top, draw horizontal lines until you reach the bottom.

CURVED-LINE CROSSHATCHING

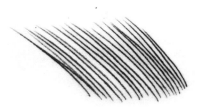

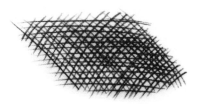

1 Start With Curving Lines
Starting at the bottom, draw slightly curved lines with equal distance between them.

2 Add Oppositional Lines
Starting at the bottom of the opposite side, draw lines curving up at an angle.

3 Finish
Starting at the top, draw horizontal lines until you reach the bottom.

Defining Shapes

It's very satisfying to change a flat image into one with volume. Follow these simple steps for very pleasing results.

 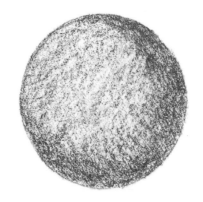 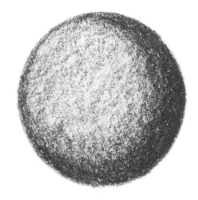

1 Cover the Shape
Within the shape you wish to color, cover the entire area with strokes of the same width as shown.

2 Add a Layer to the Perimeter
Using the side of the point of your pastel or other medium and applying more pressure, add more color to the perimeter and lower right of the shape. This gives the effect of light coming from the upper left.

3 Finish
Apply more color with even strokes to the perimeter and lower right to blend the color evenly and deepen the shadow.

Pastel Patterns

Pastels are unique in their effect. Soft strokes can swirl into beautiful patterns. Try this demo and then use your imagination for creating new patterns that suit your picture.

1 Apply Color
Begin by using the side of your pastel to apply an even tone.

2 Draw Some Shapes
Using an edge of the pastel, draw a pattern.

3 Finish
Apply a third color to complete your pattern.

Deepening Values

These demos show how simple spacing of lines and dashes can change the *value* of a color. The value of a color refers to its lightness or darkness.

VERTICAL LINES

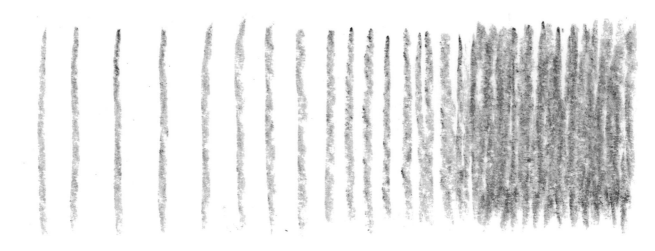

1 Space the Lines Far Apart
Here, the color looks very light with lots of white space between the lines.

2 Space the Lines Closer Together
By spacing vertical lines closer together, your color will appear darker. This method applies to the use of markers, pencils, crayons and pastels.

DASHES

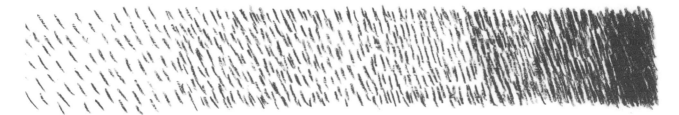

Diagonals
Apply small diagonal strokes leaving a lot of space in between. By gradually leaving less space, the value of the color will deepen. This method will work for other dry media as well.

Play With Colored Pencil Layering

Here are some examples of the results you can get from layering color. Apply your own combinations to see the many useful effects you will achieve.

1 Pick a Base Color
Begin by selecting a colored pencil in a dark shade. I've used violet, a secondary color on the color wheel.

2 Go Lighter
Next, select a color of a lighter hue. I've used orange, also a secondary color. Holding your pencil at a 45-degree angle, shade over the darker color. The resulting hue can be used to create interesting effects.

3 Go Darker
Apply a third third secondary color. I used a shade of green here to demonstrate its effect after applying it over the violet.

1 Apply Color
Holding your pencil at a 45-degree angle, use medium pressure to apply color.

2 Add a Second Color
Apply a medium shade of orange one third down the yellow.

3 Finish
Apply medium red to the remaining bottom third. To blend these colors further, you can lightly apply yellow over all of the color.

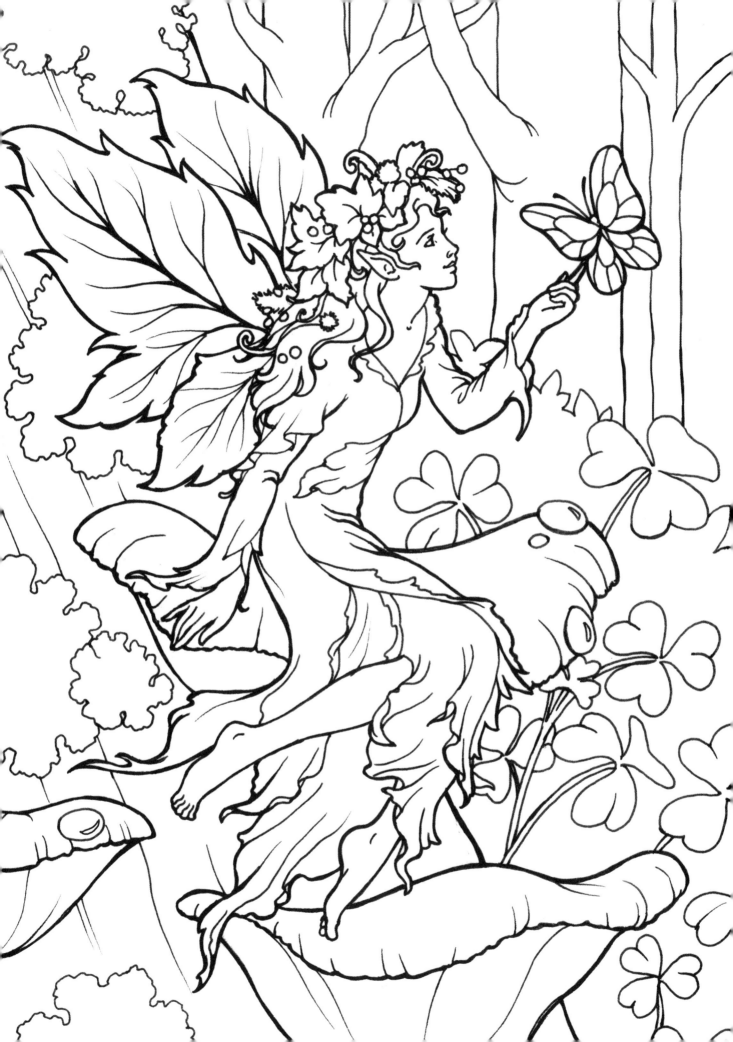

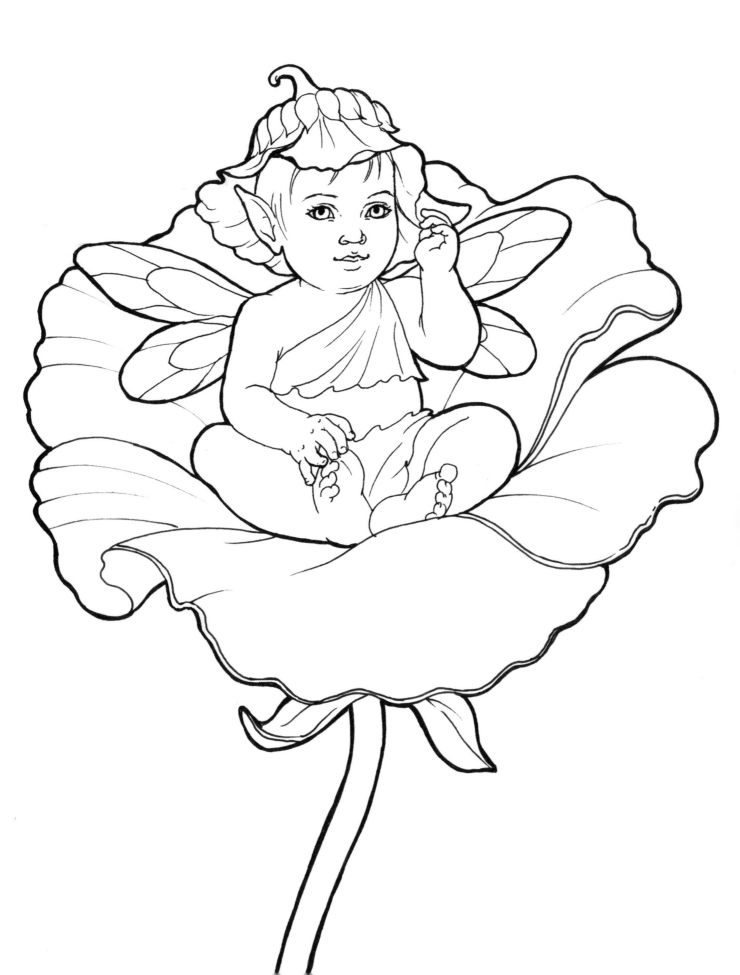

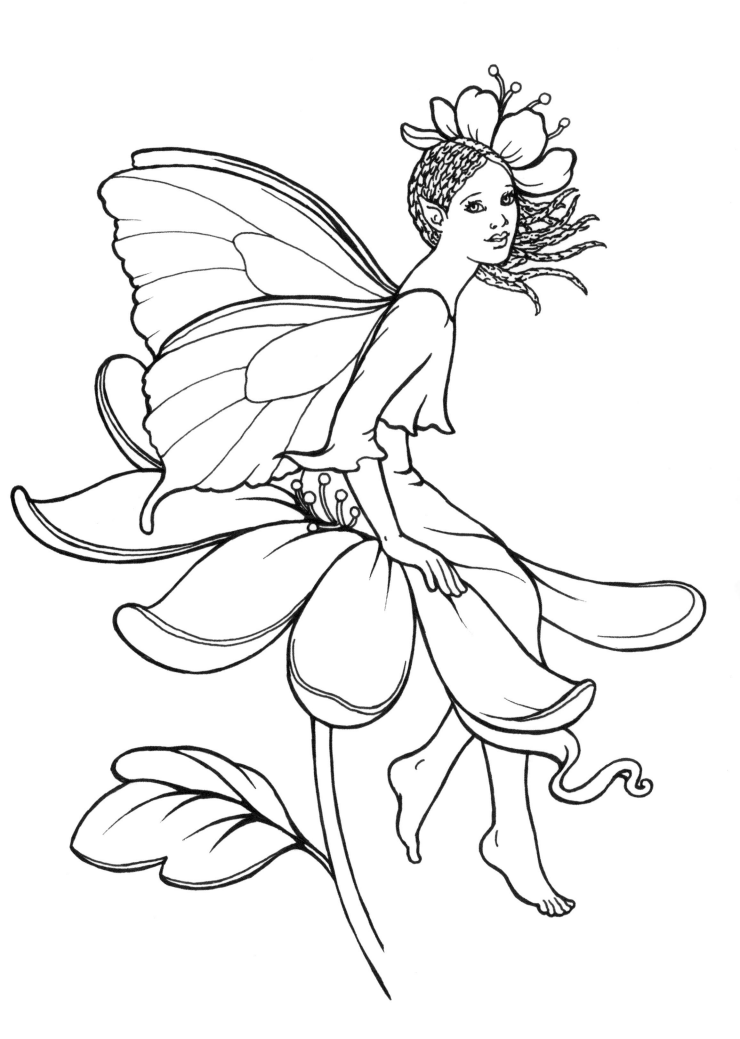

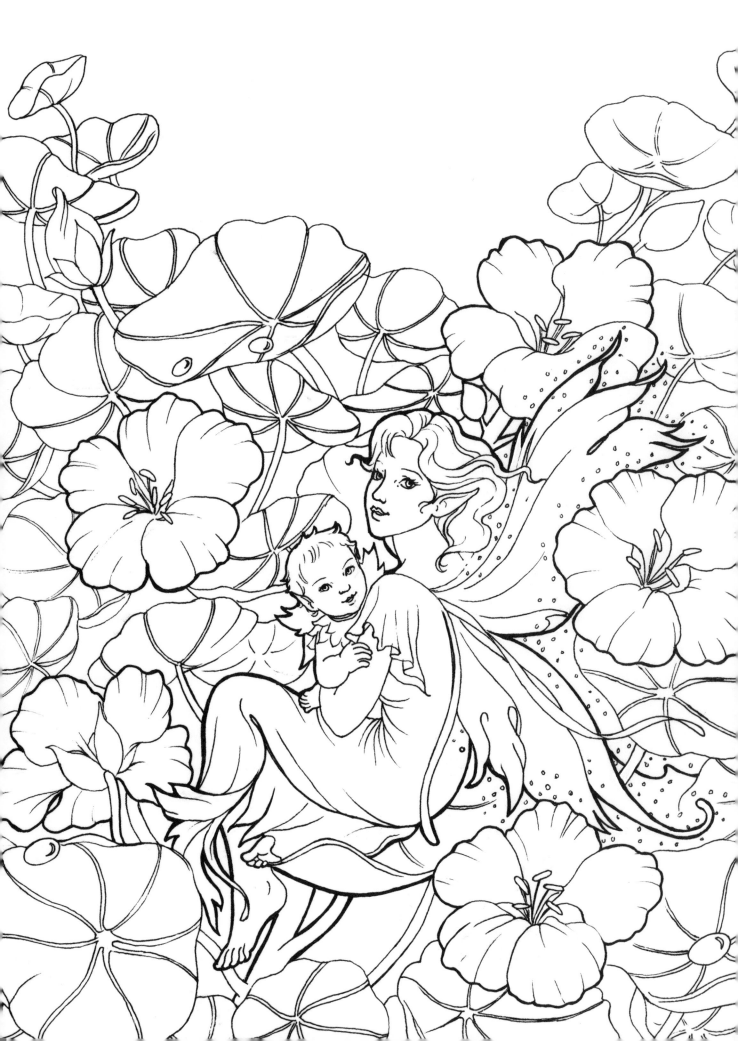

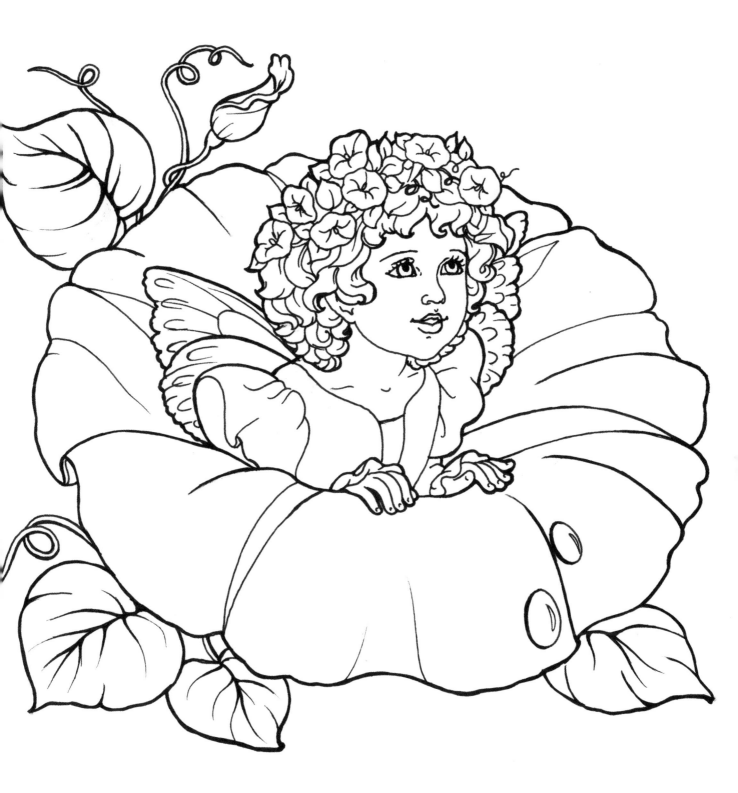

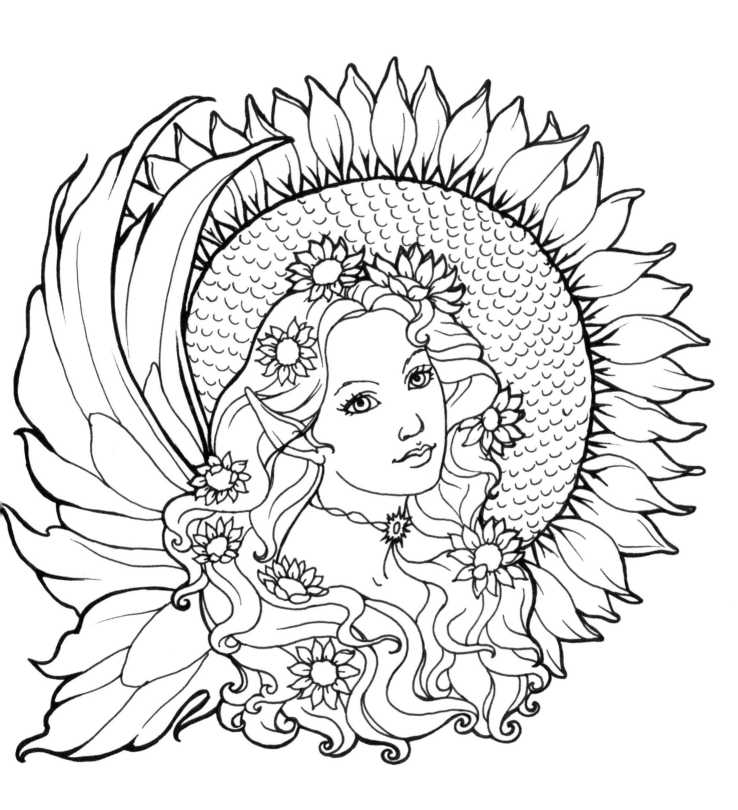

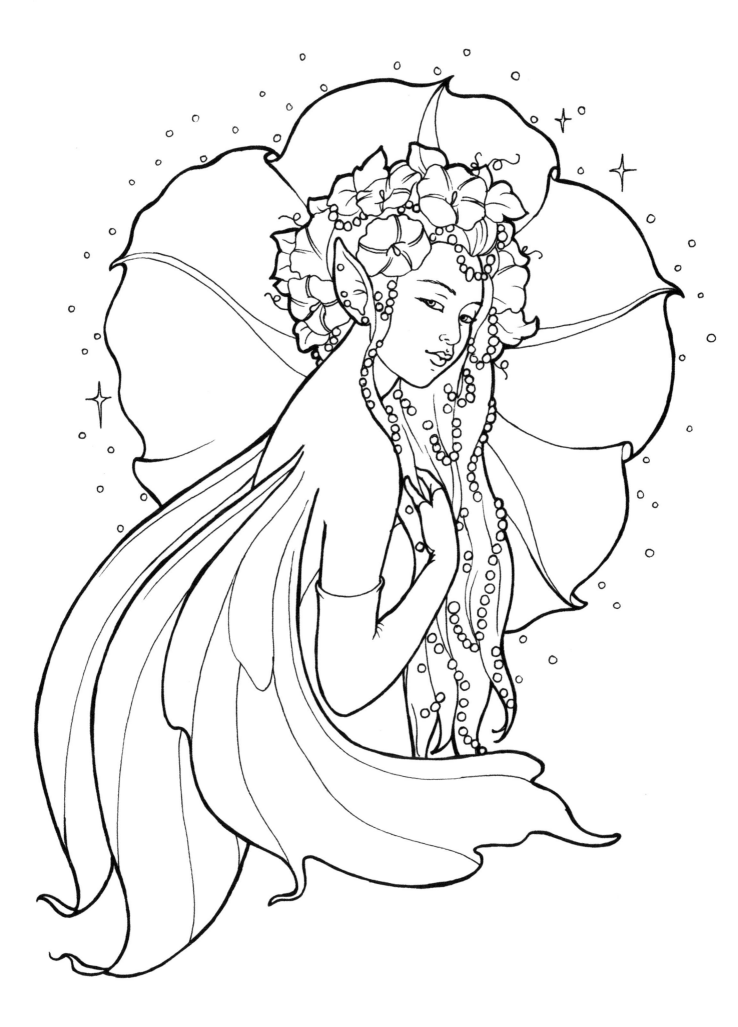

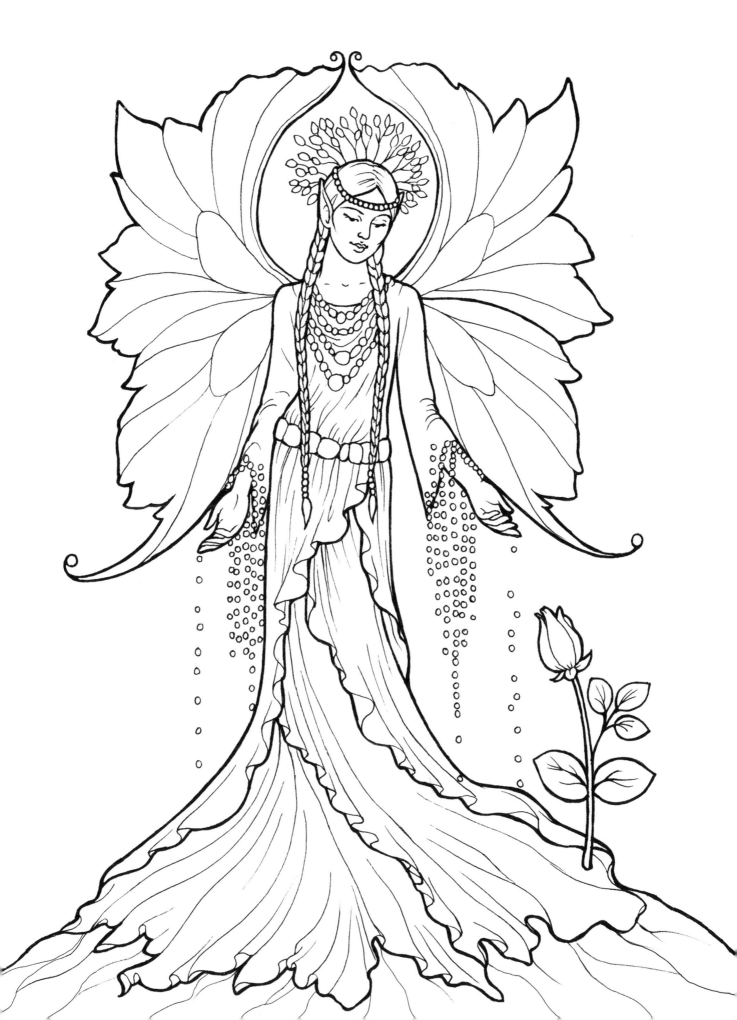

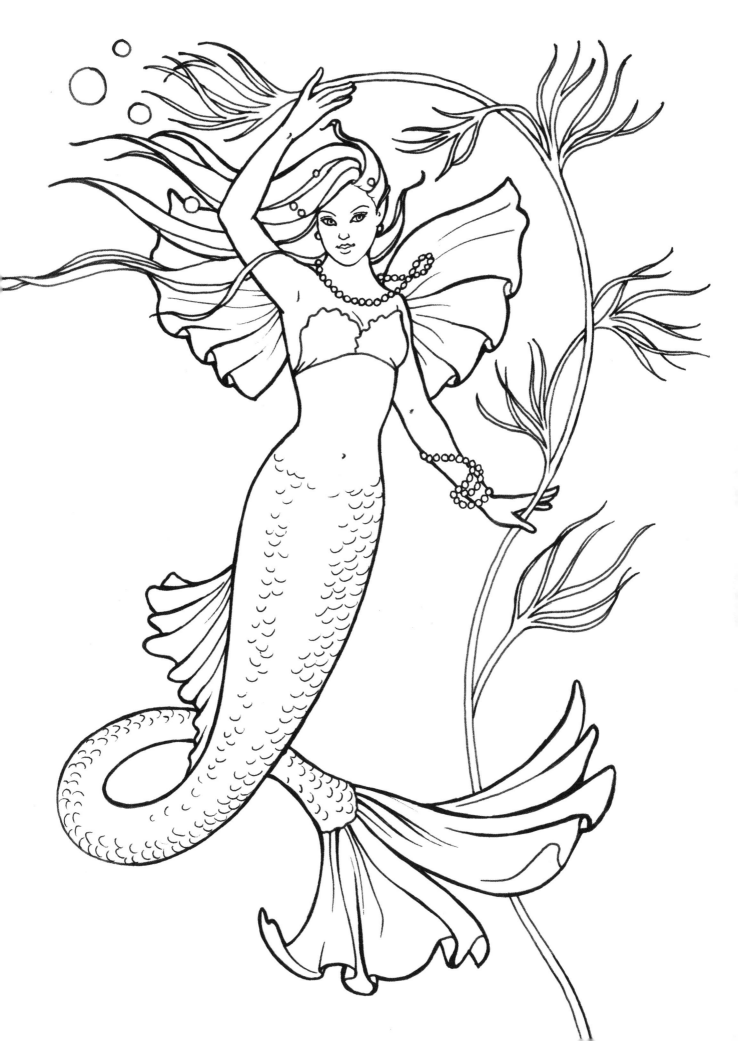

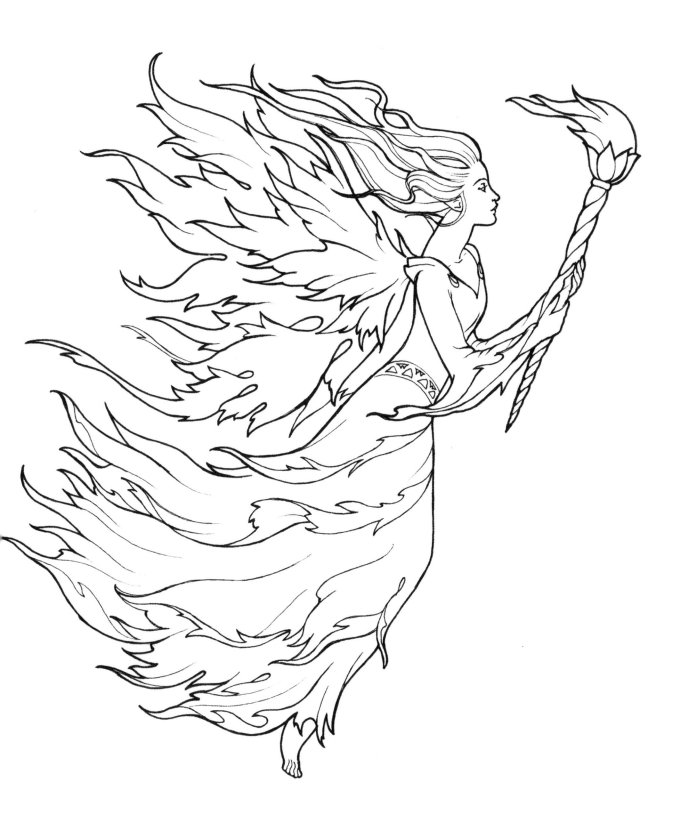

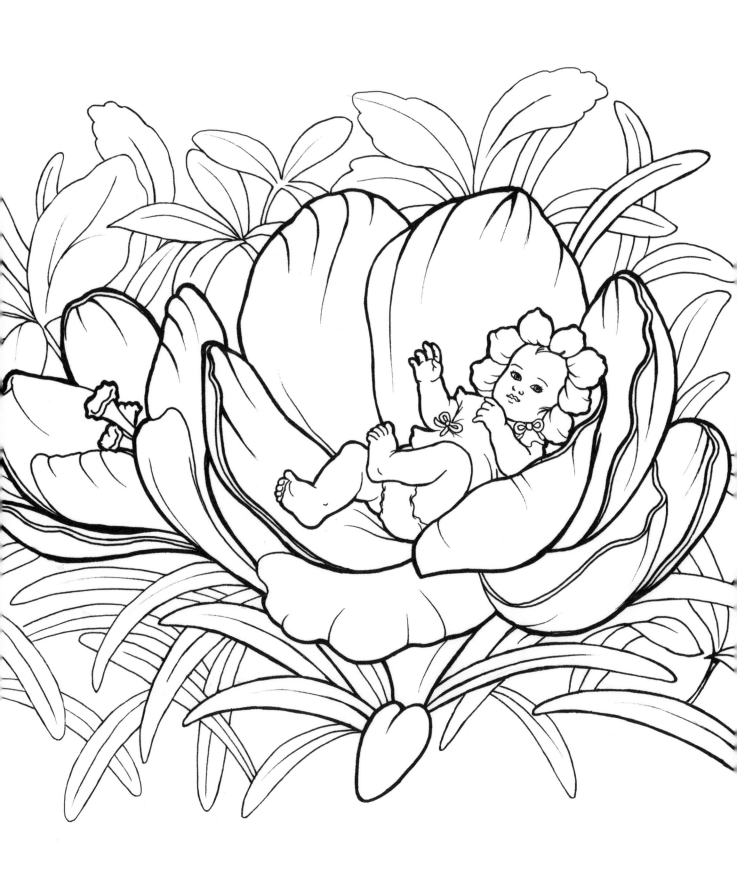

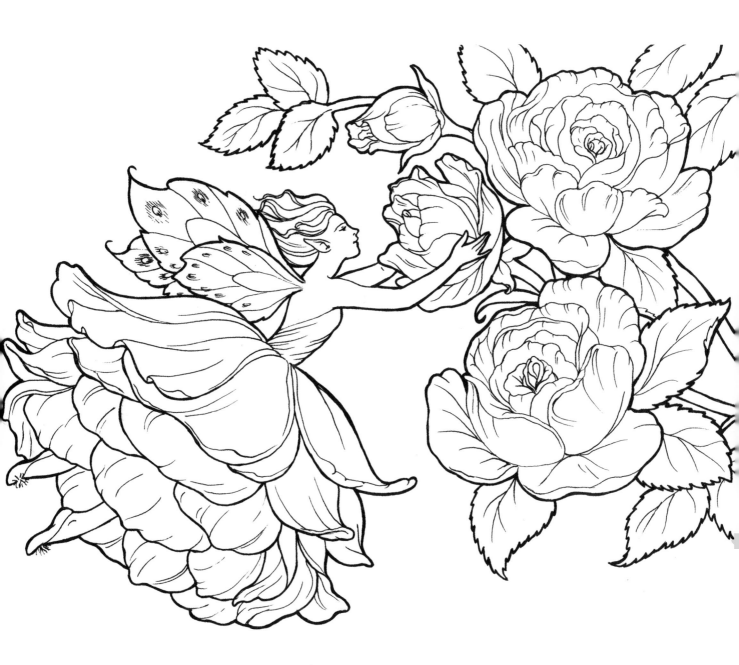

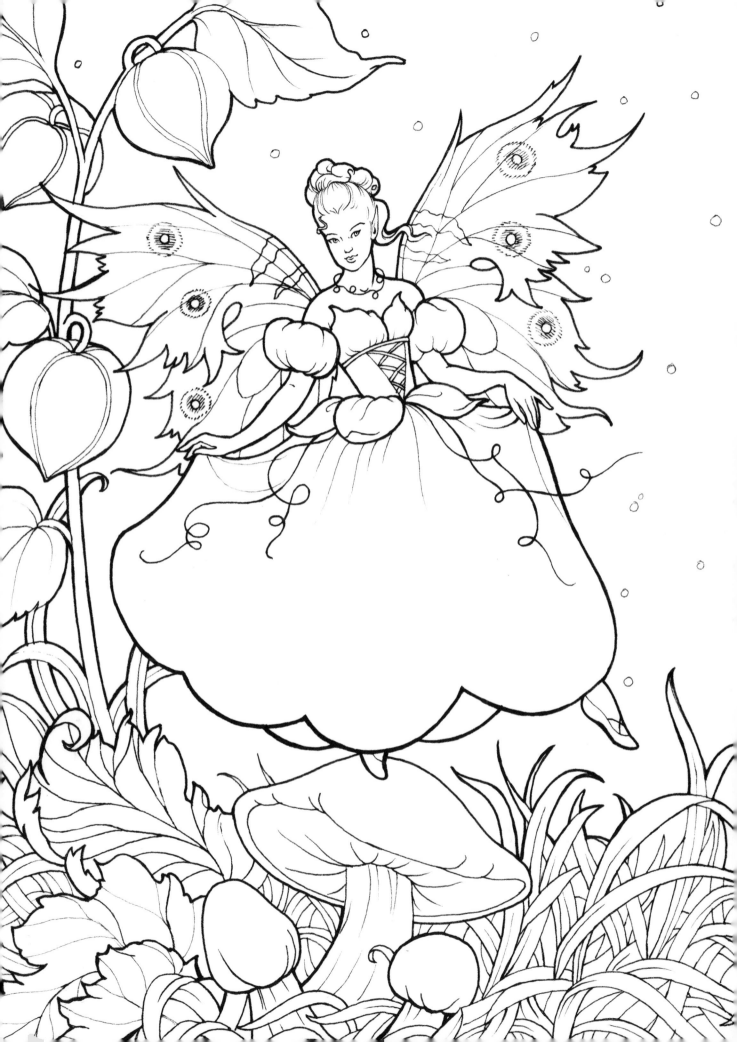

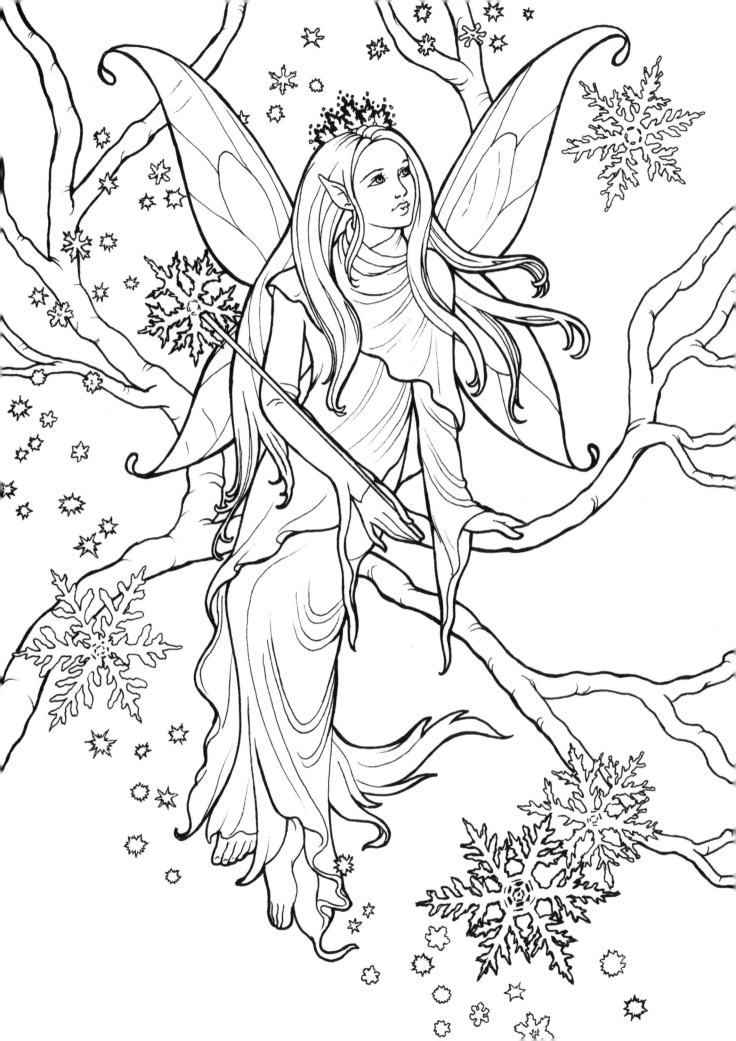

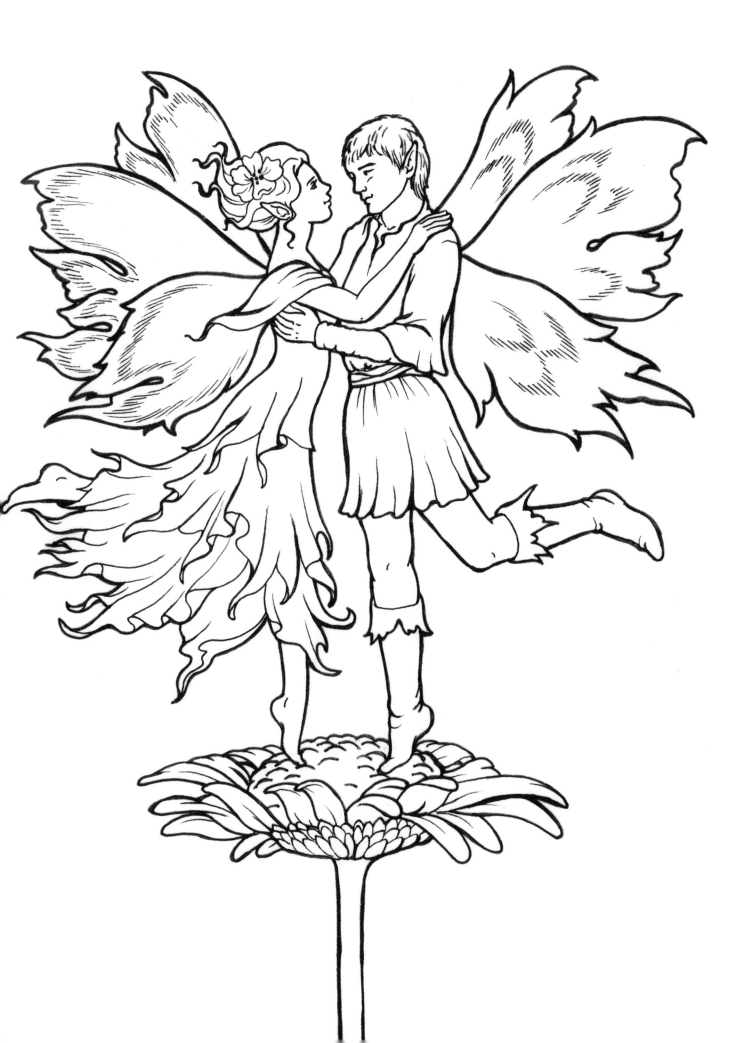

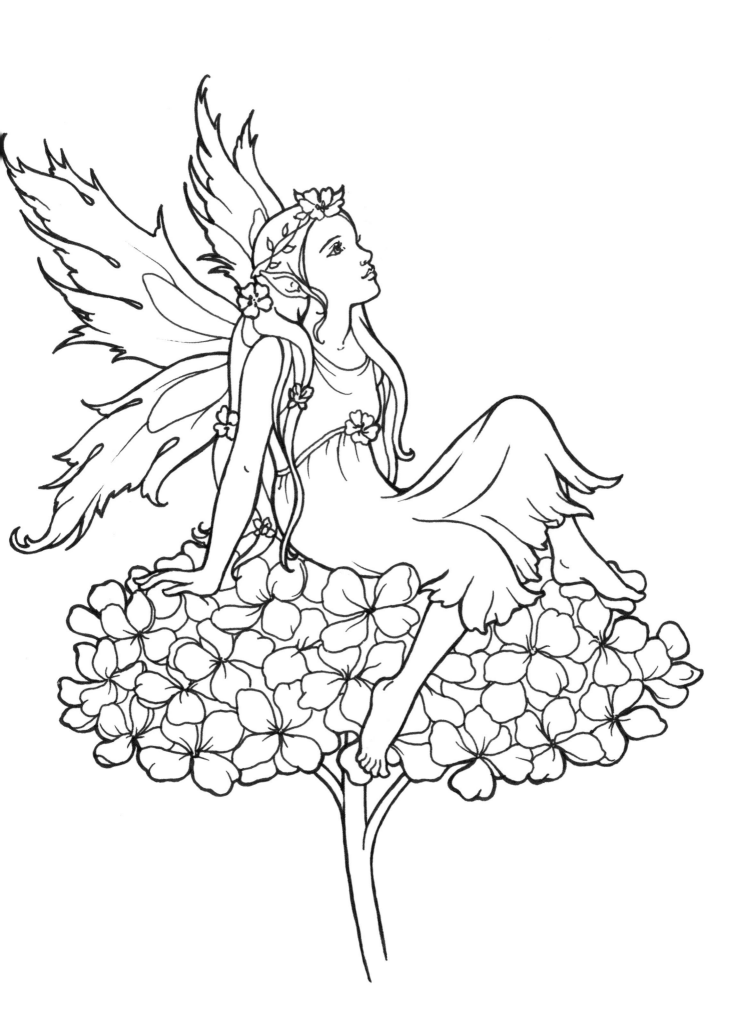

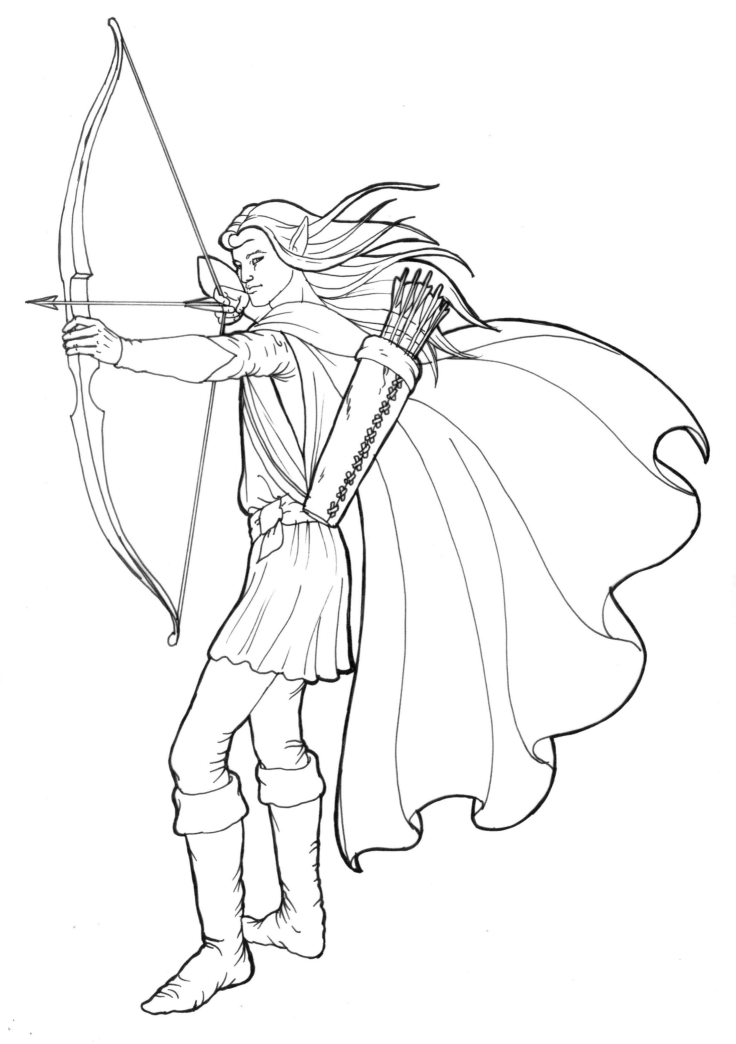

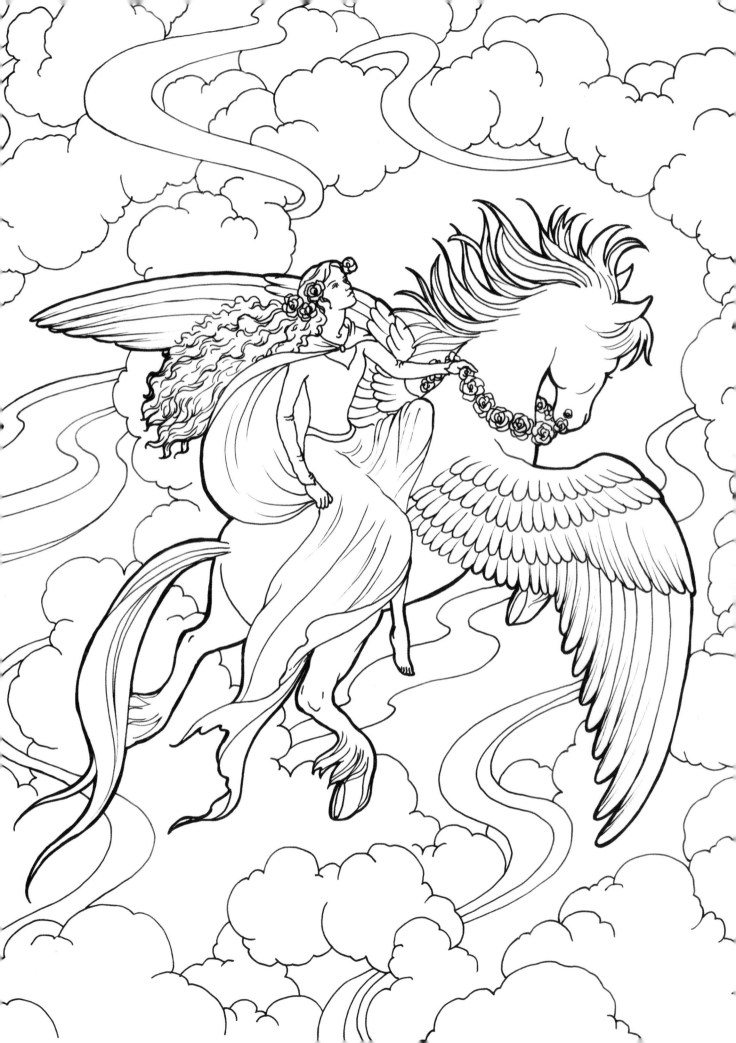

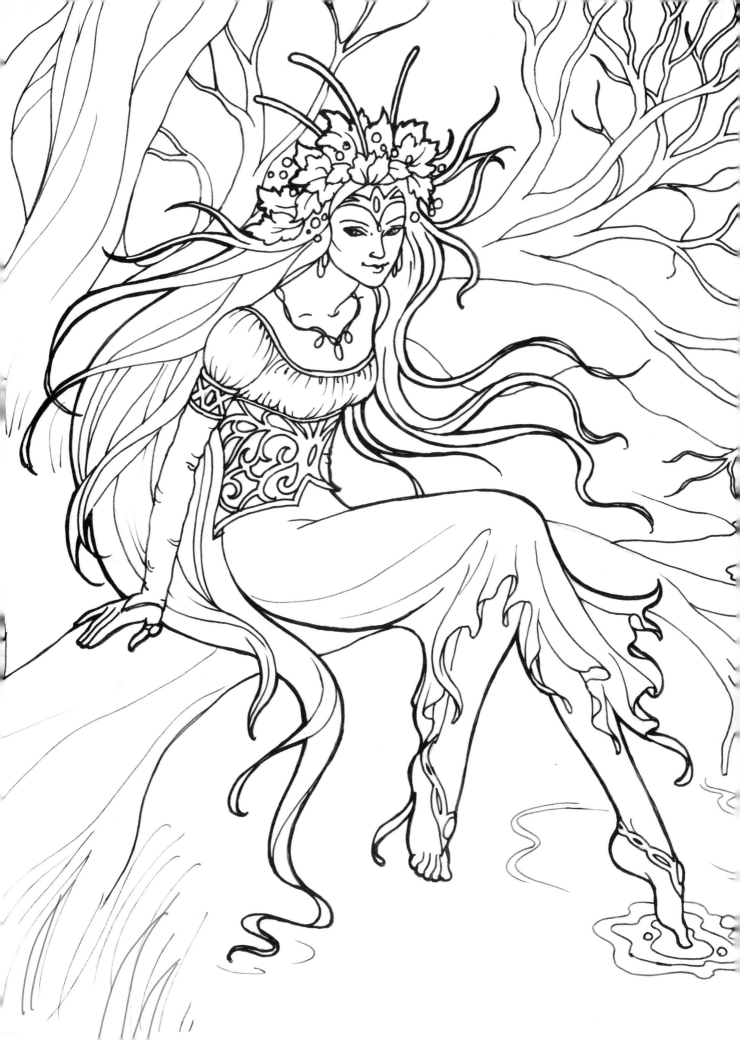

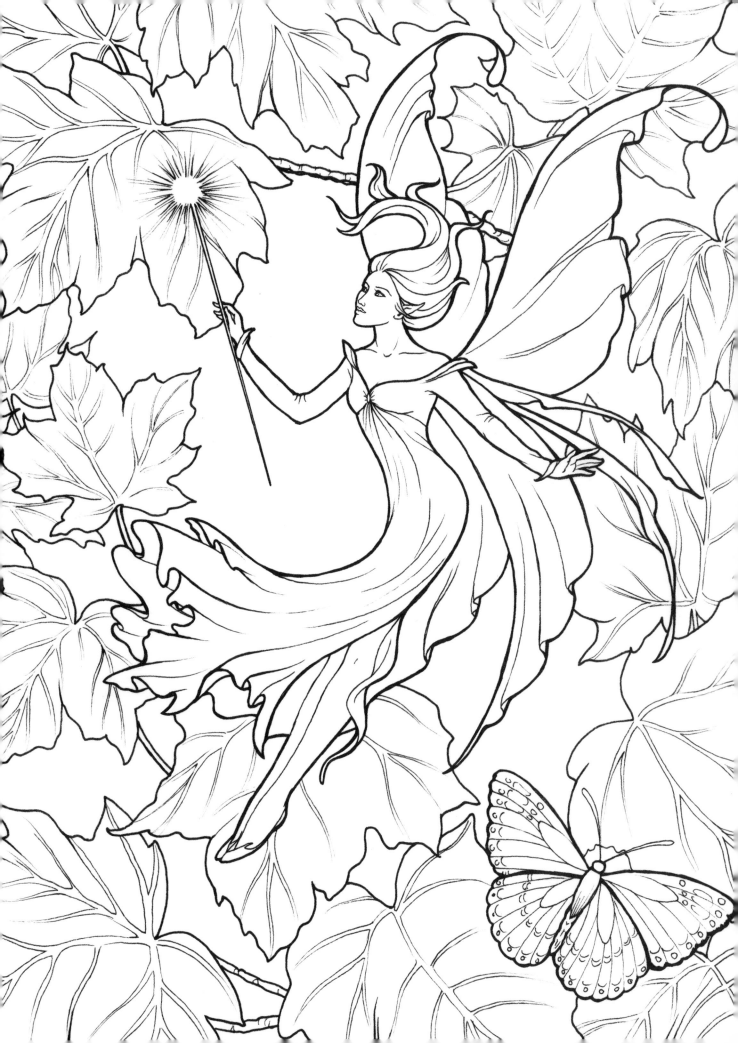

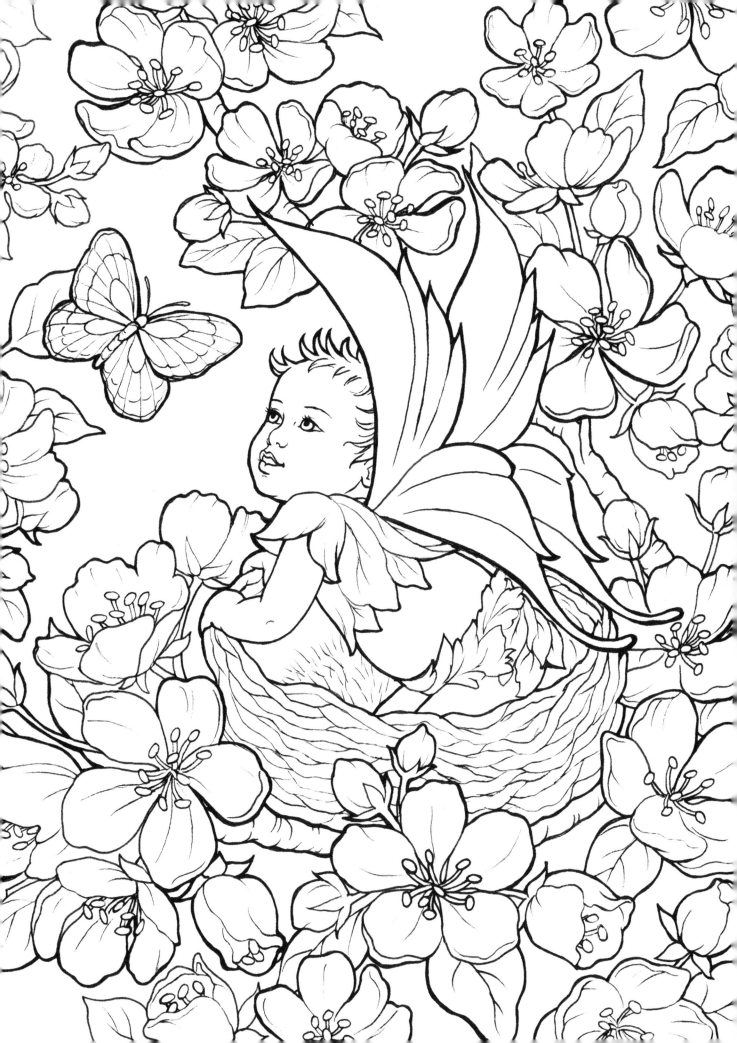

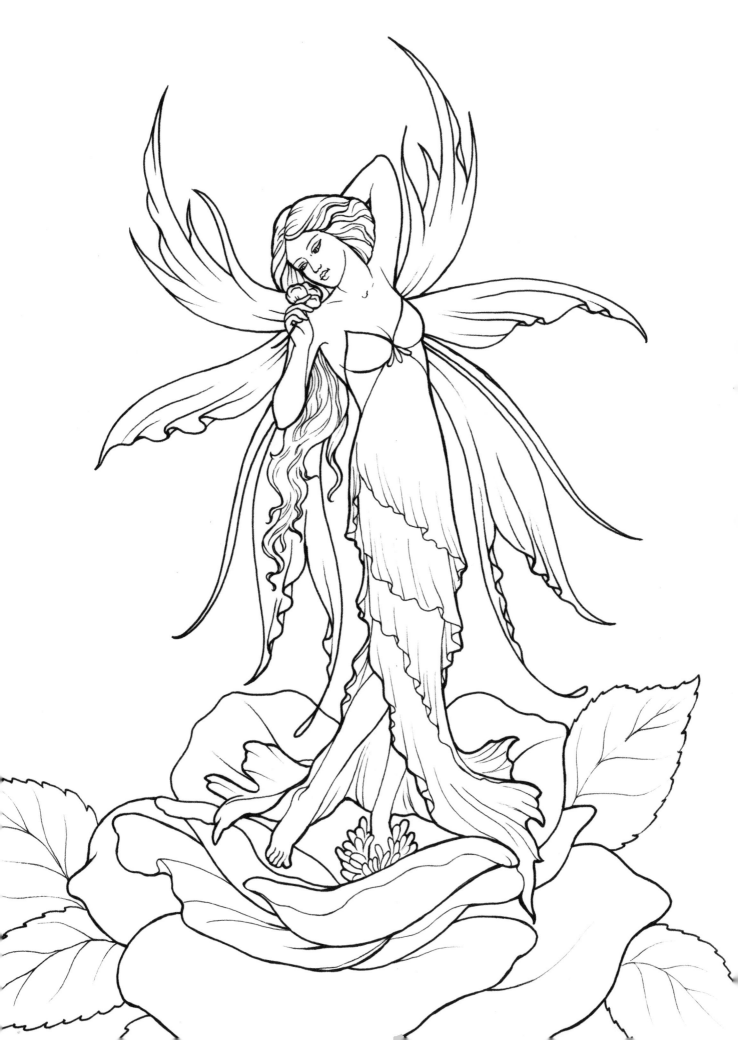

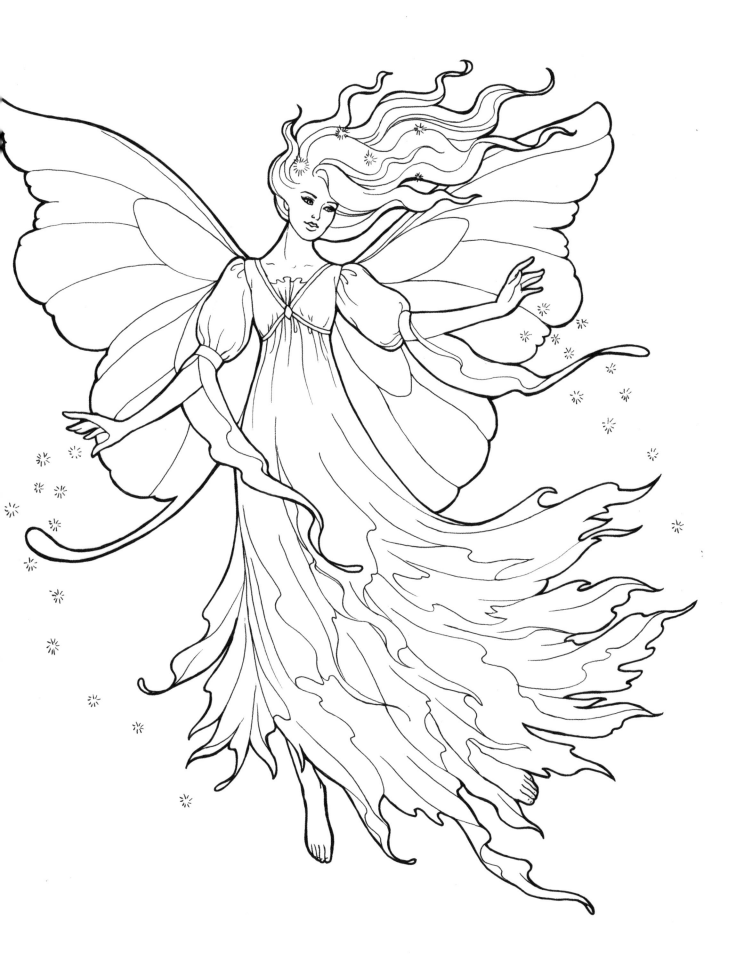

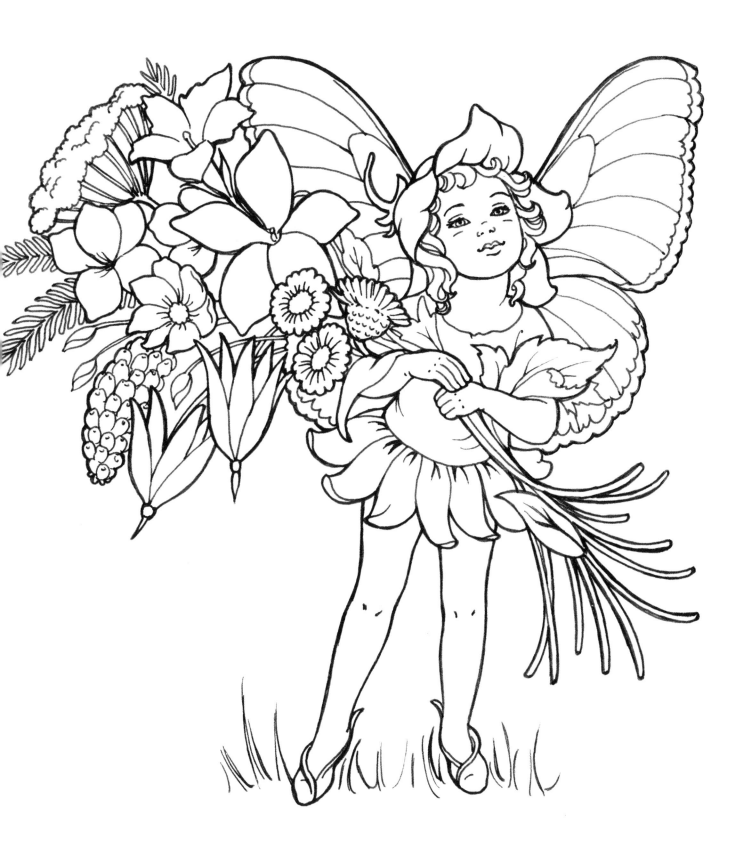

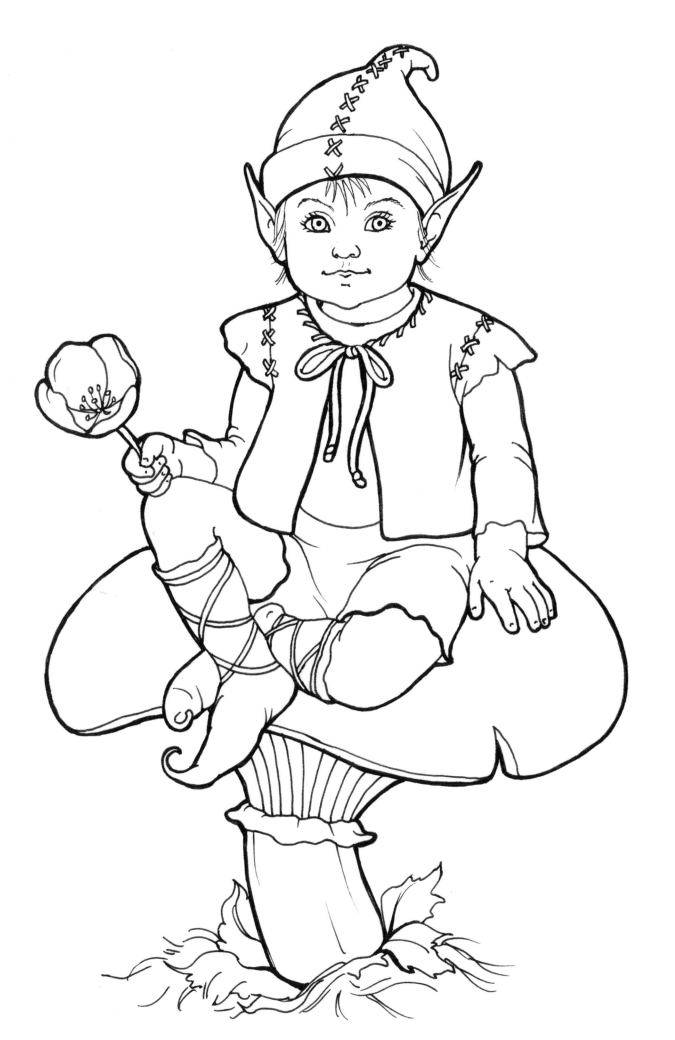

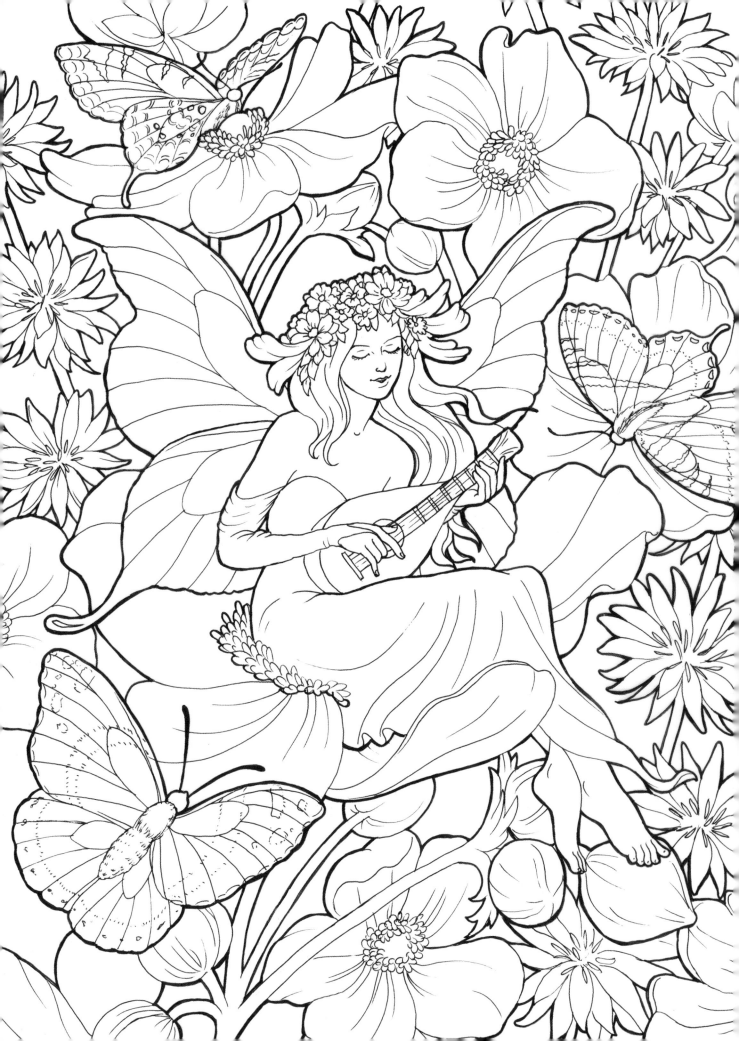

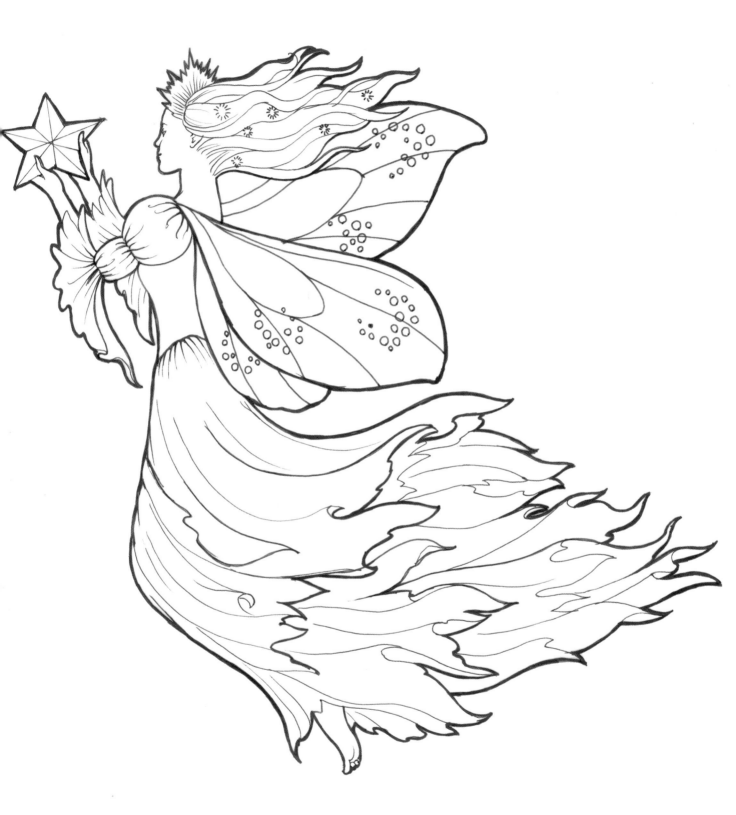

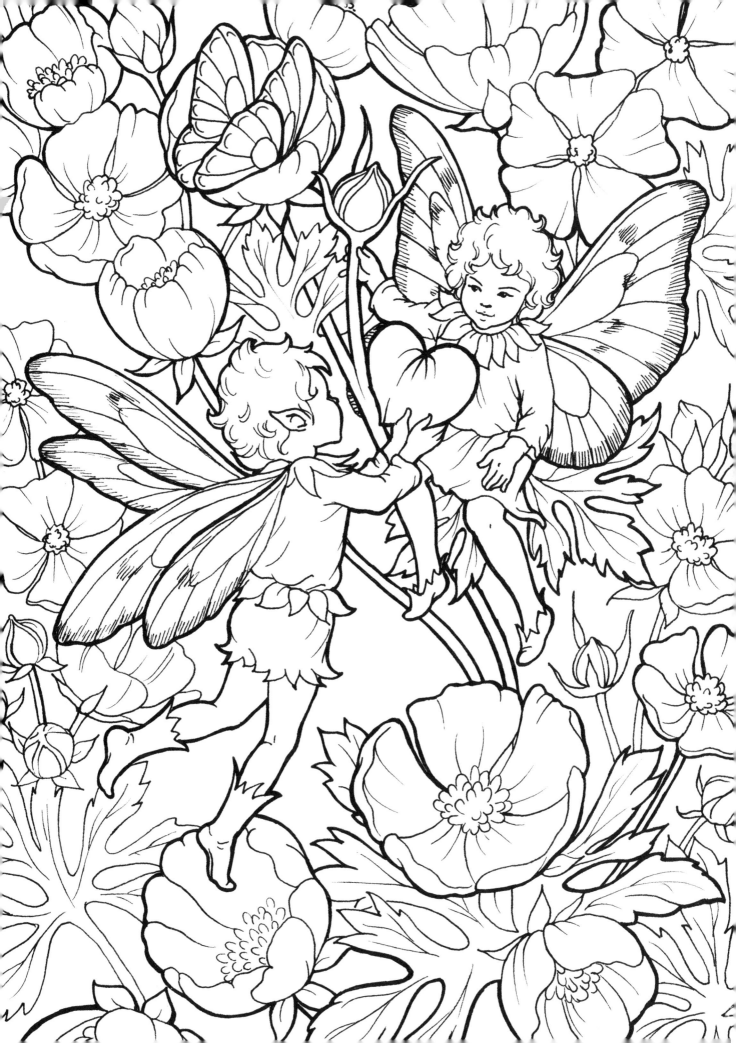

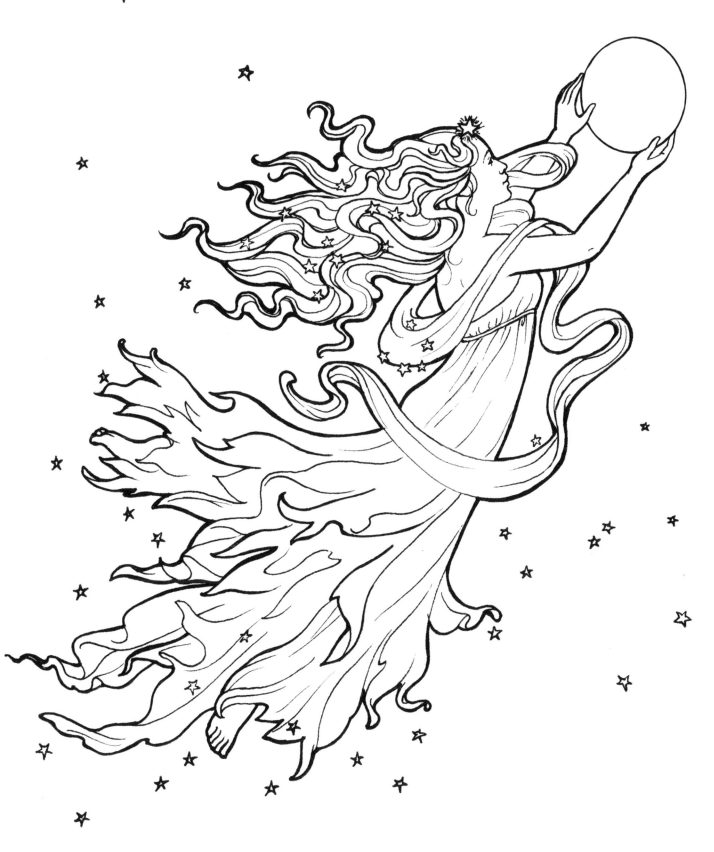

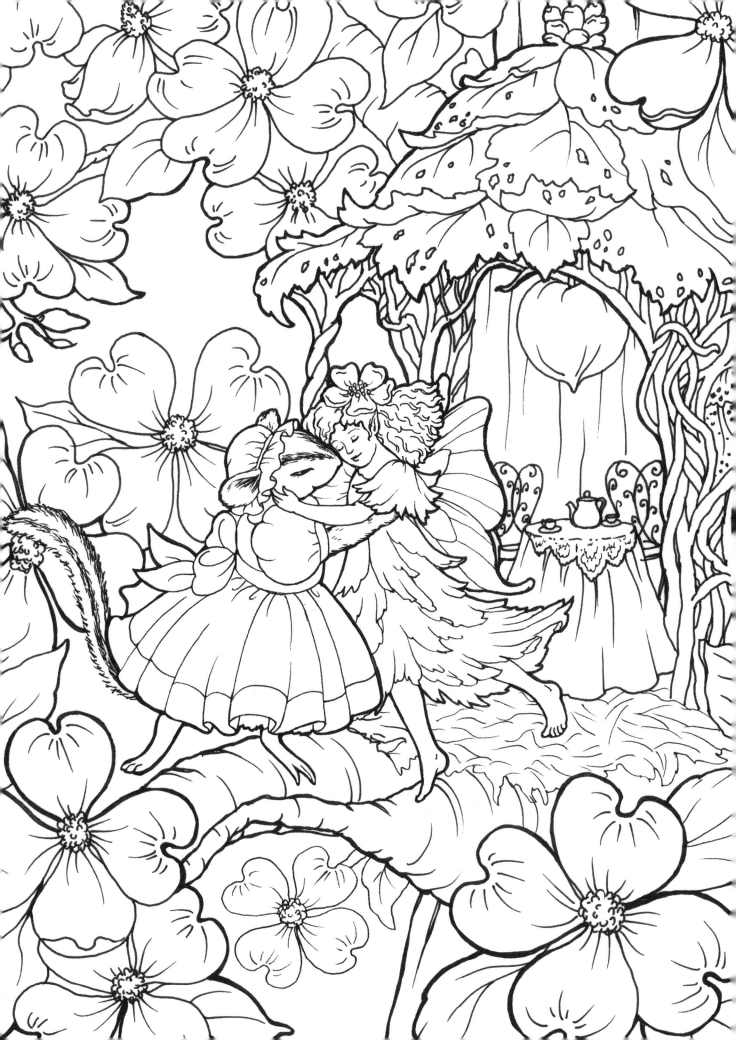

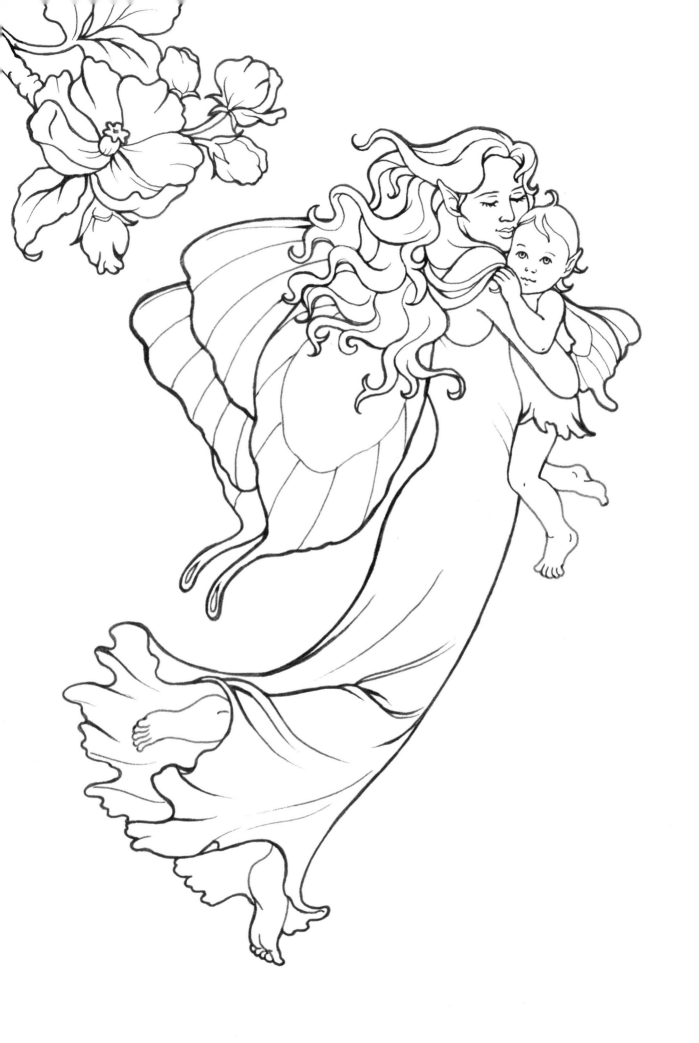

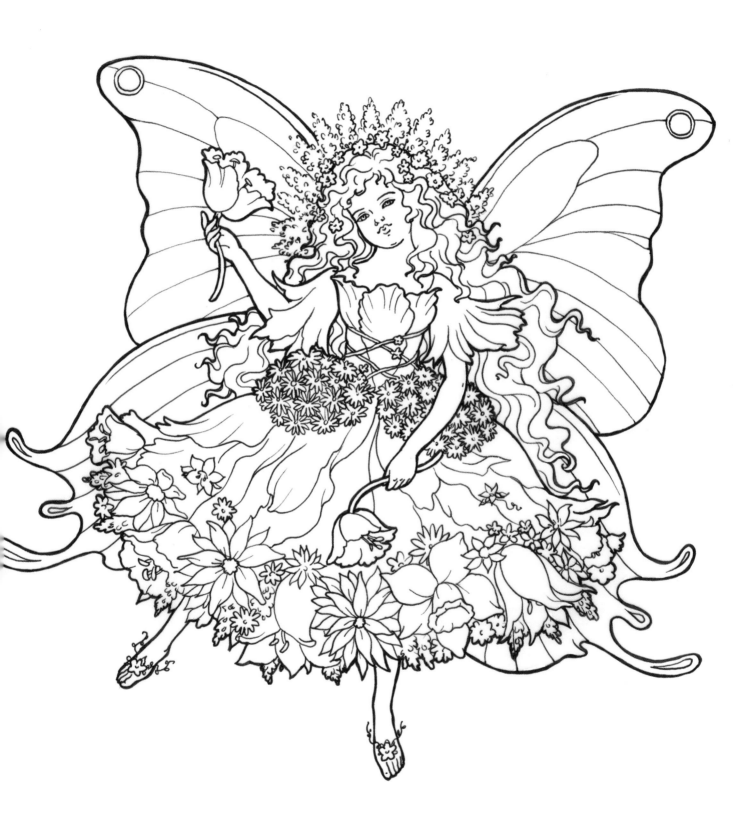

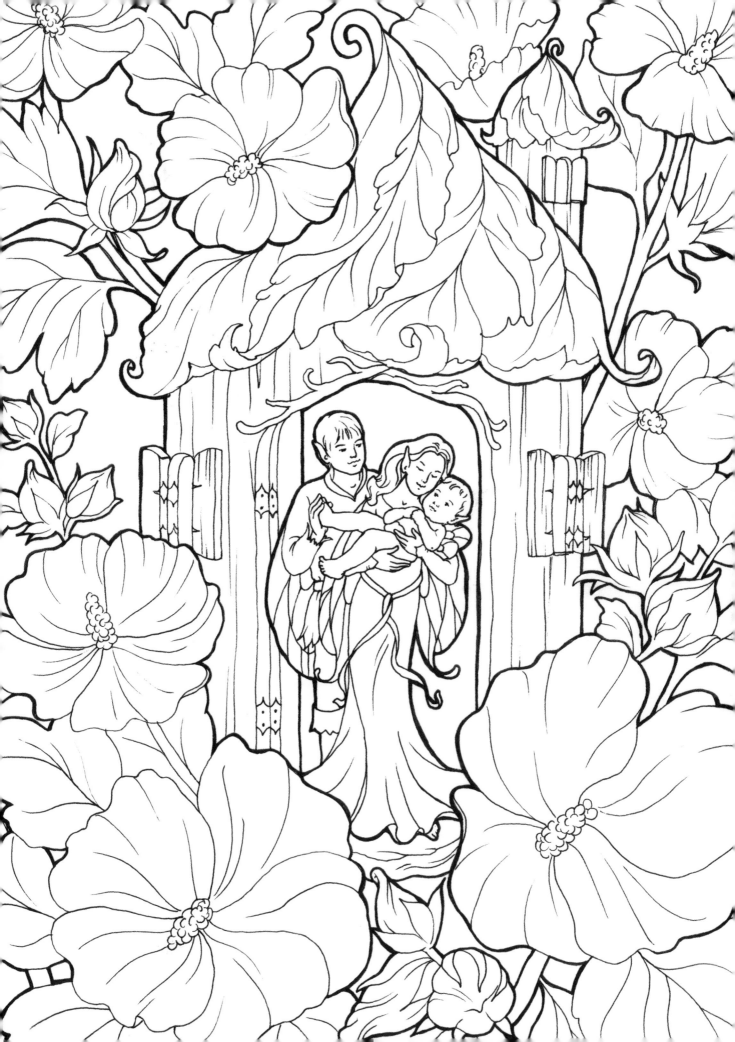

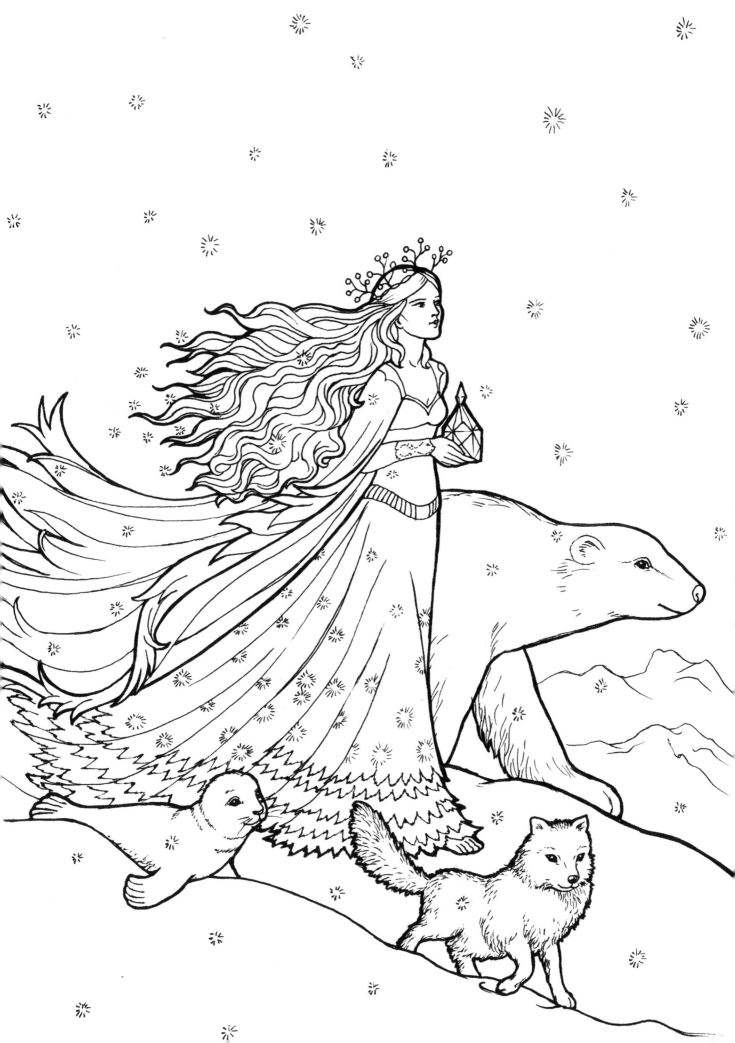

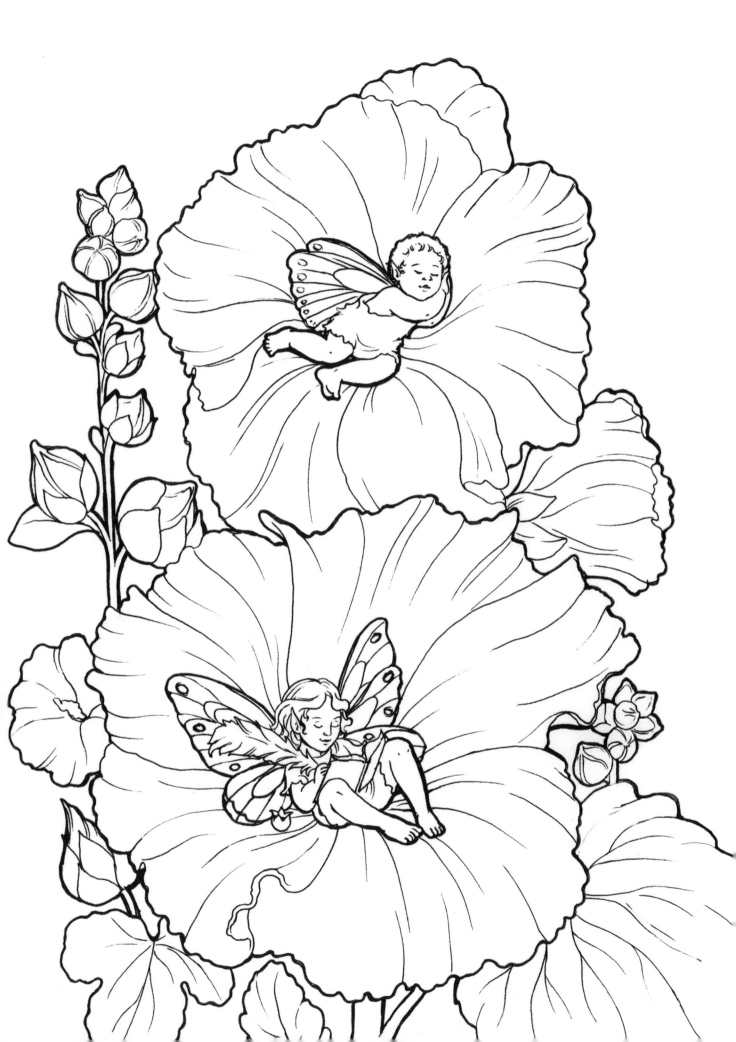

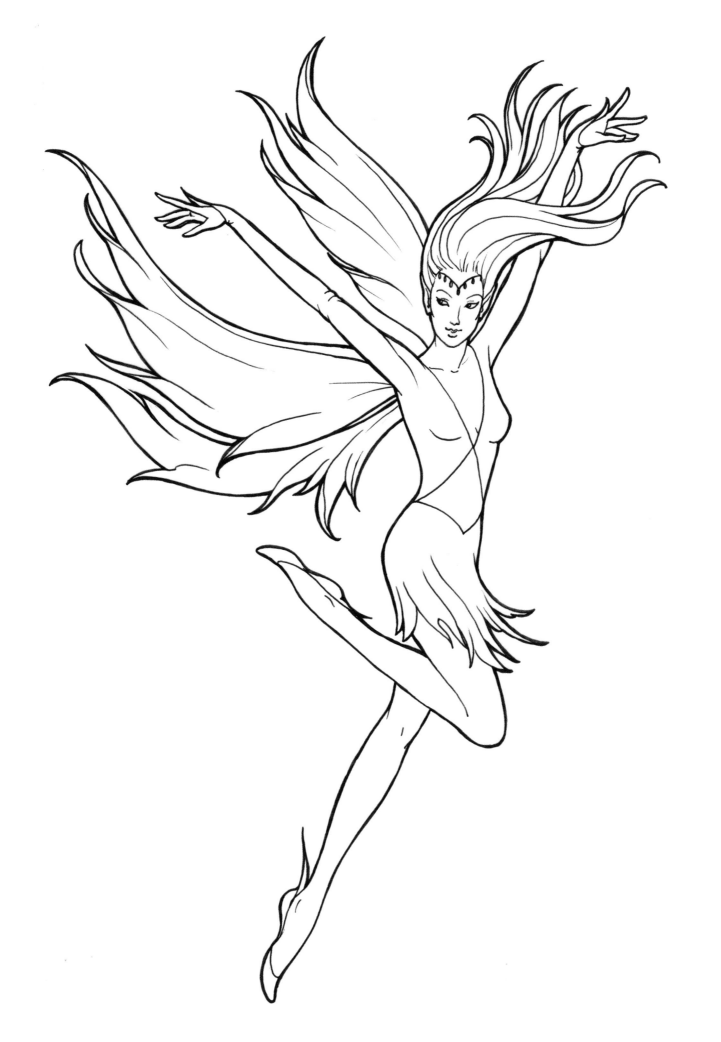

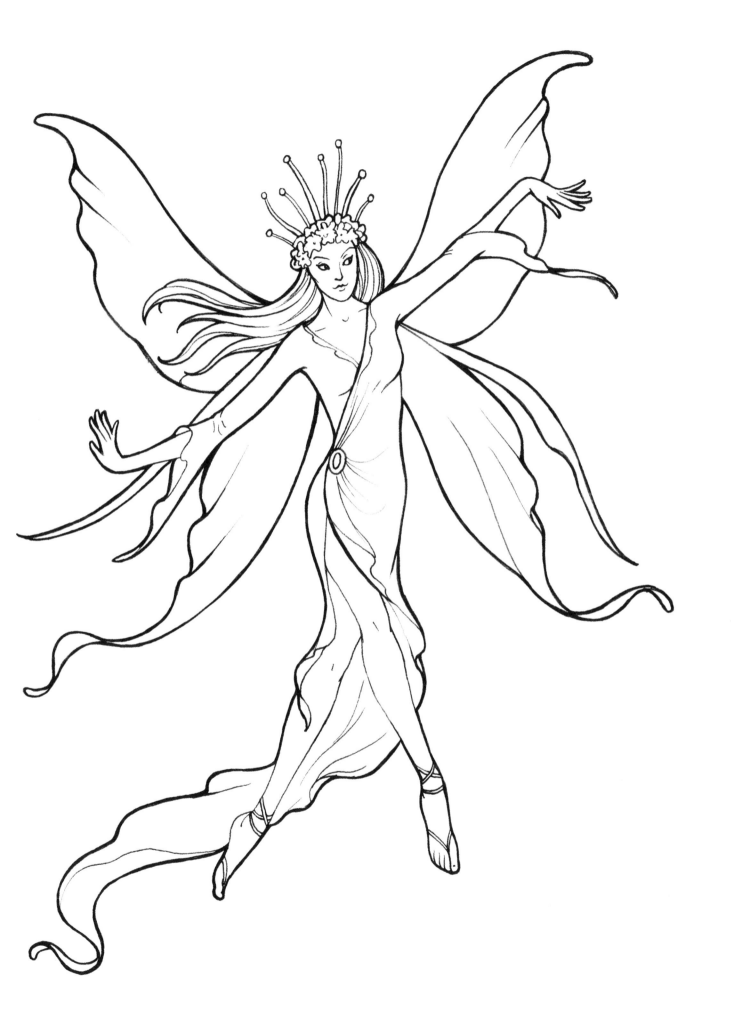

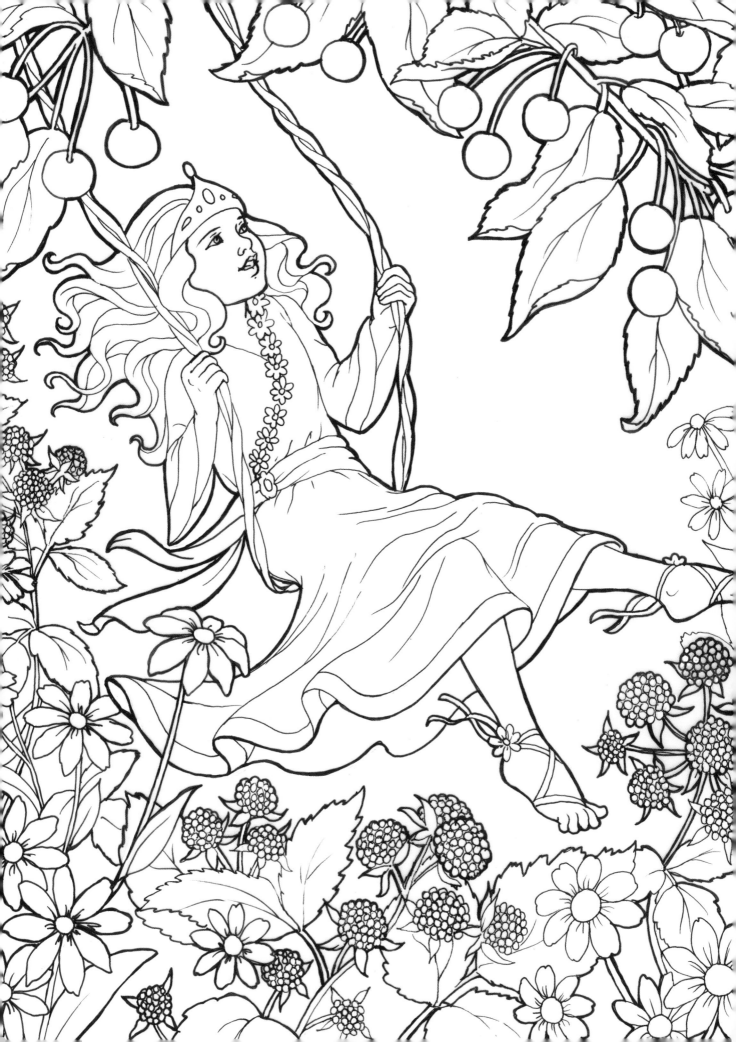

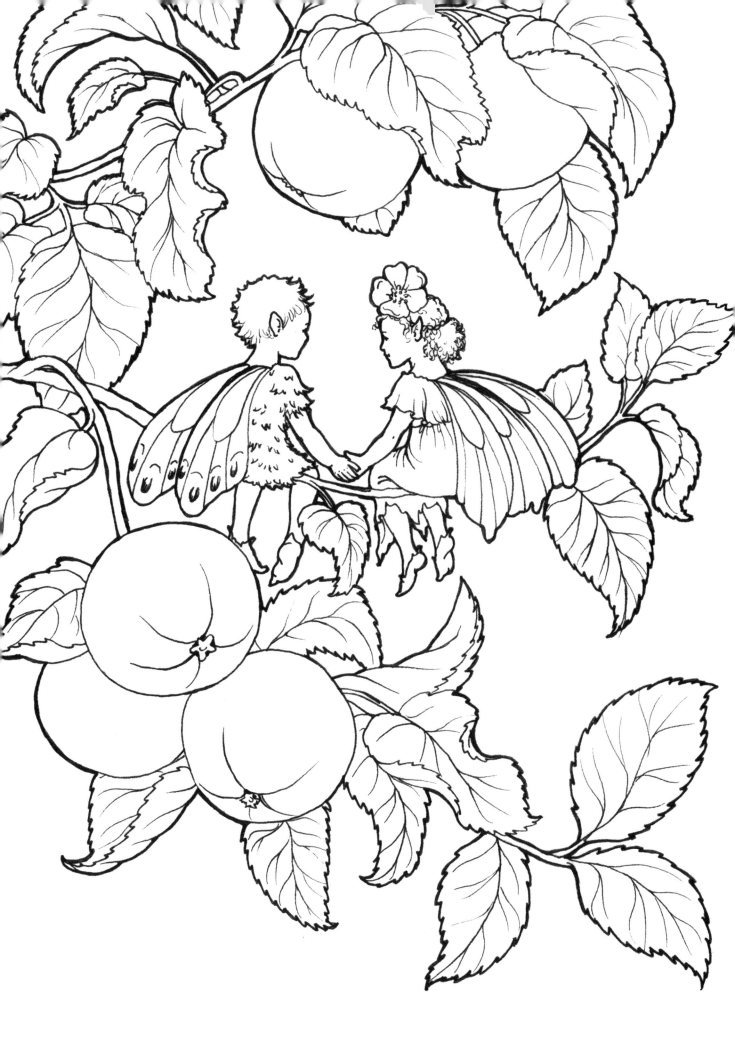

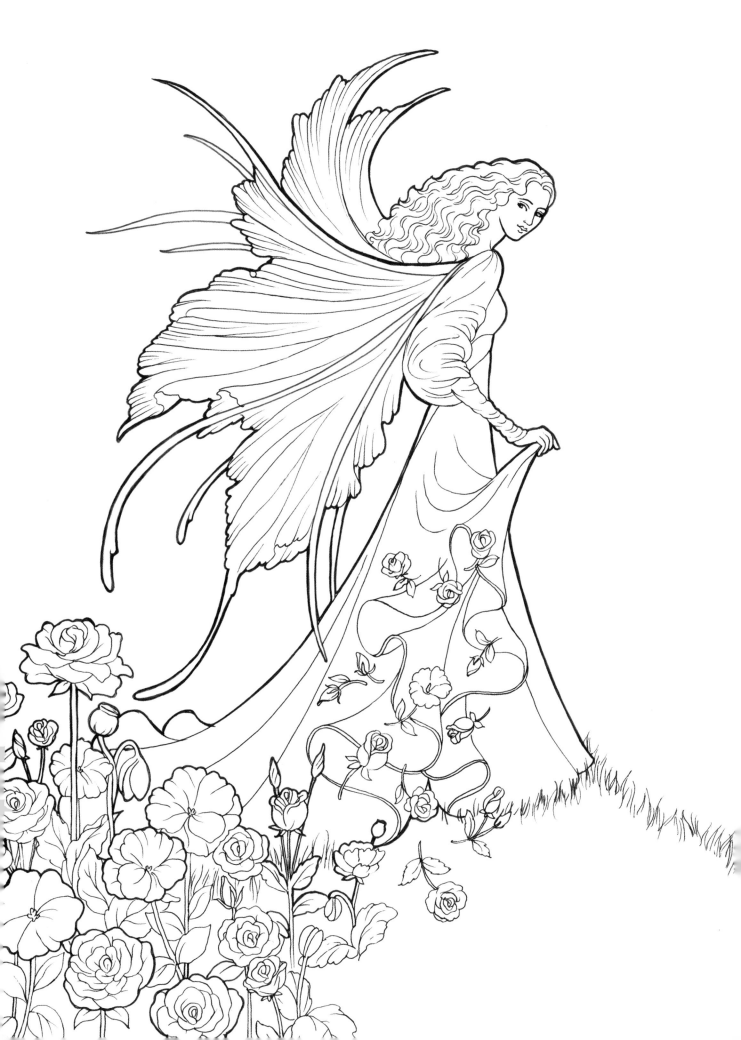

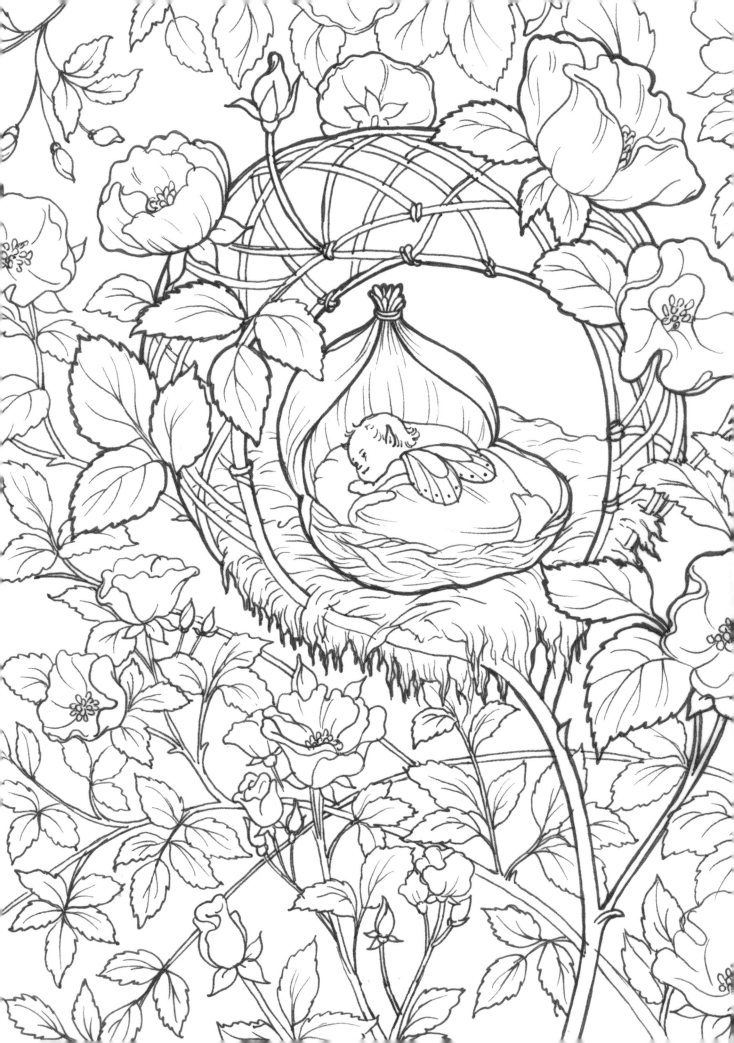

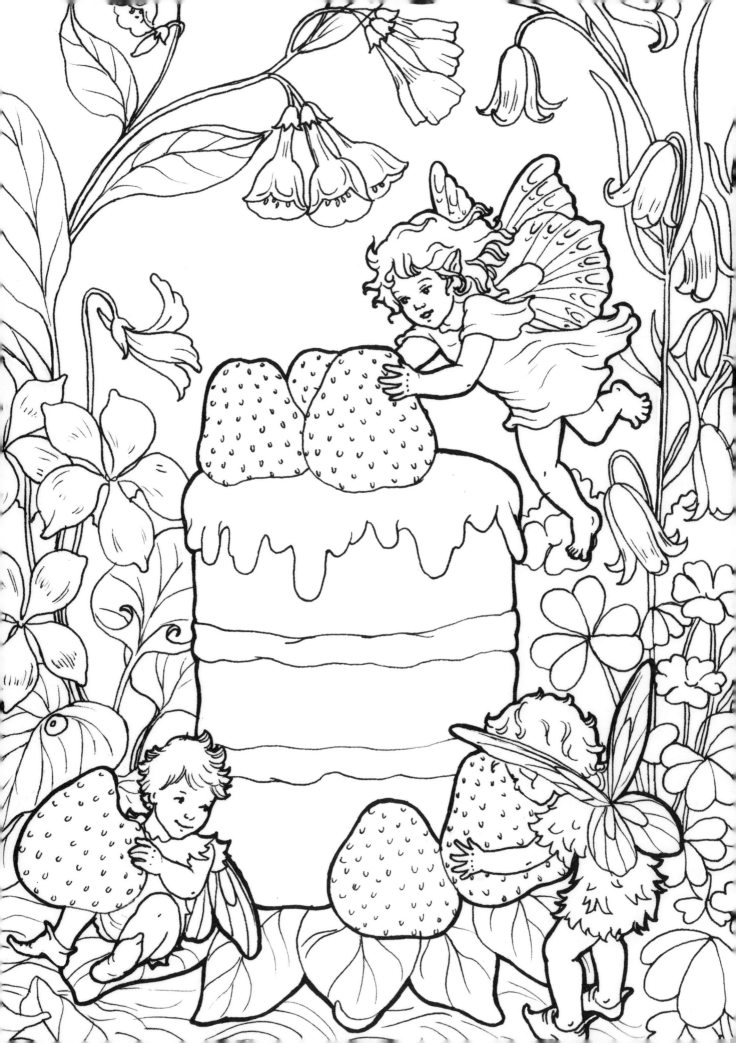

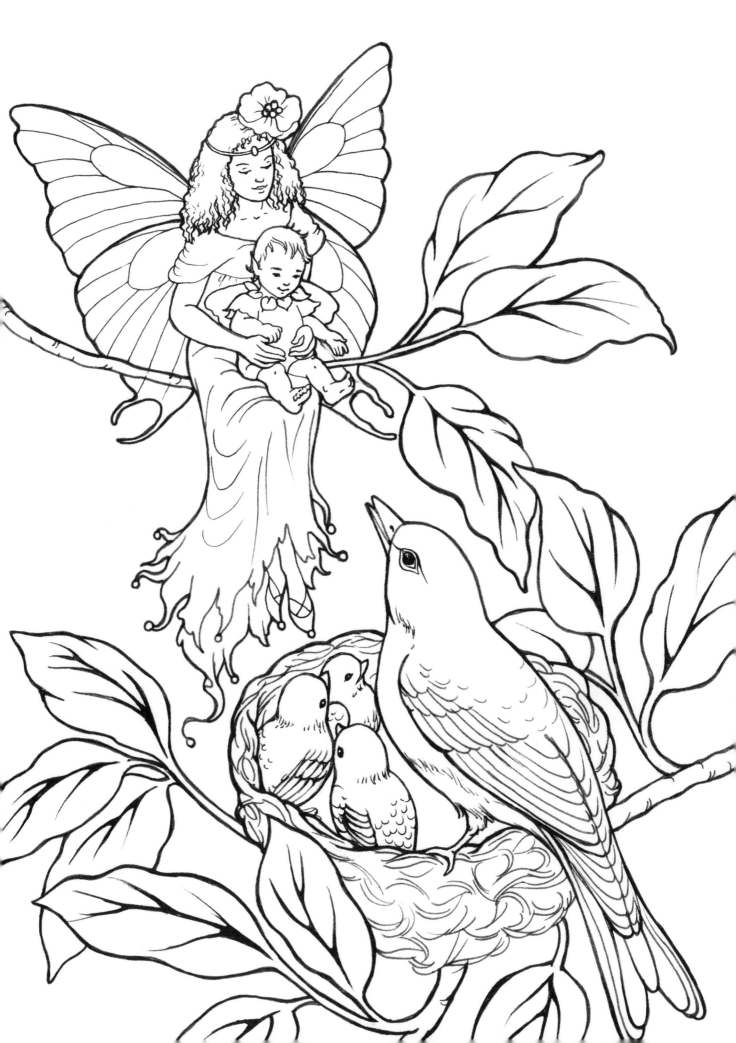

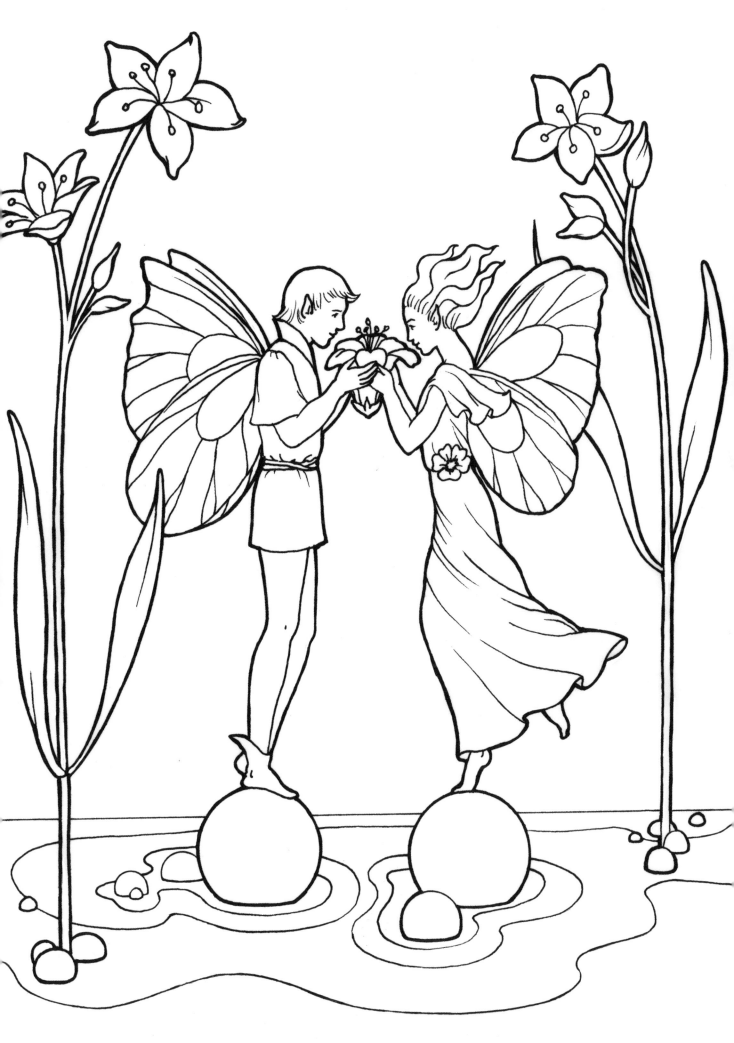

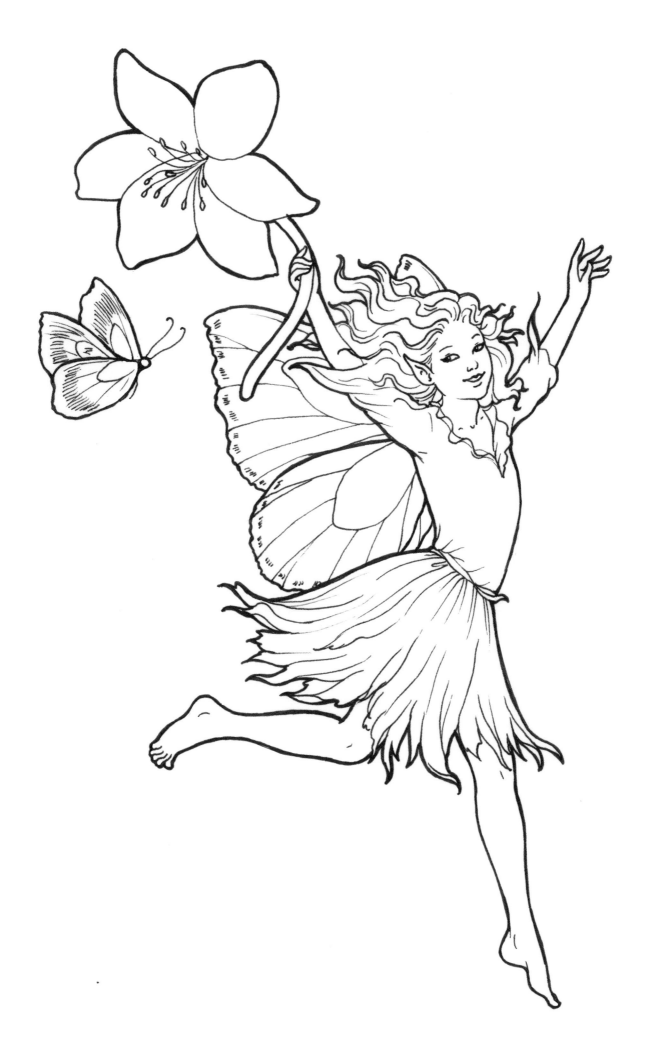

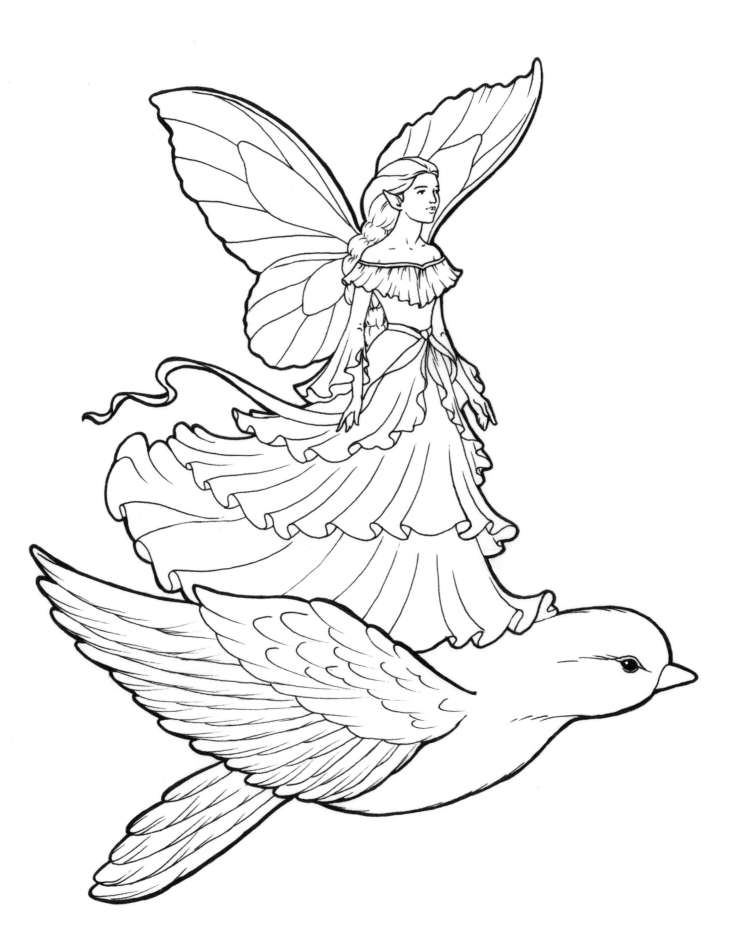

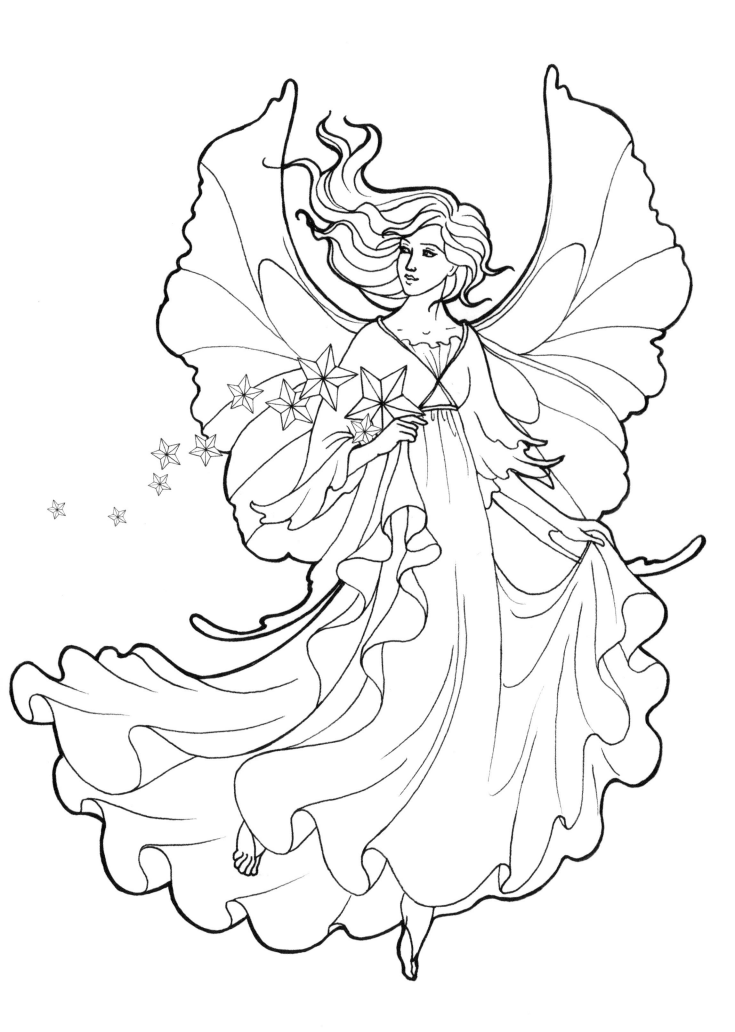

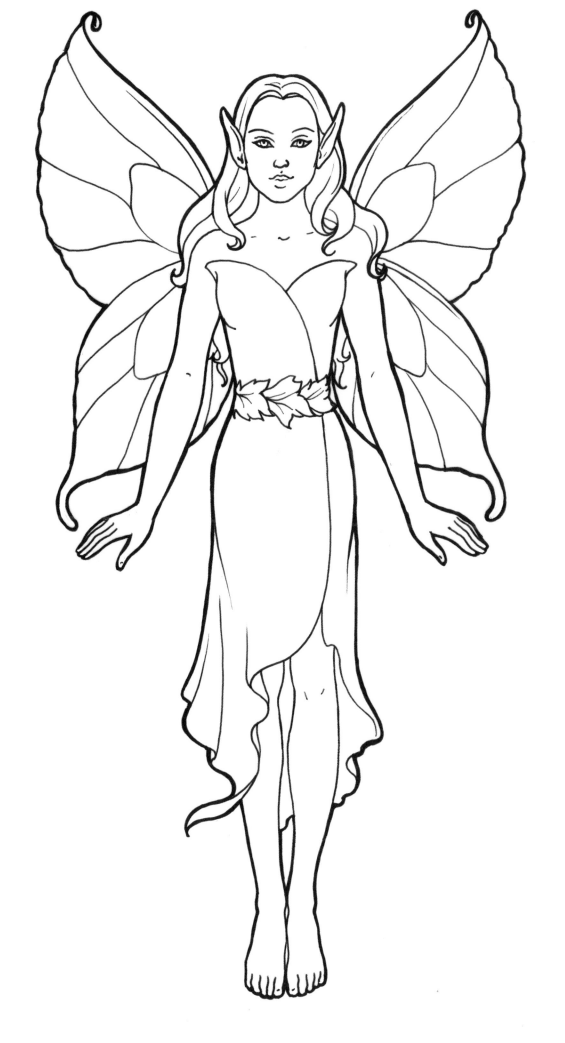

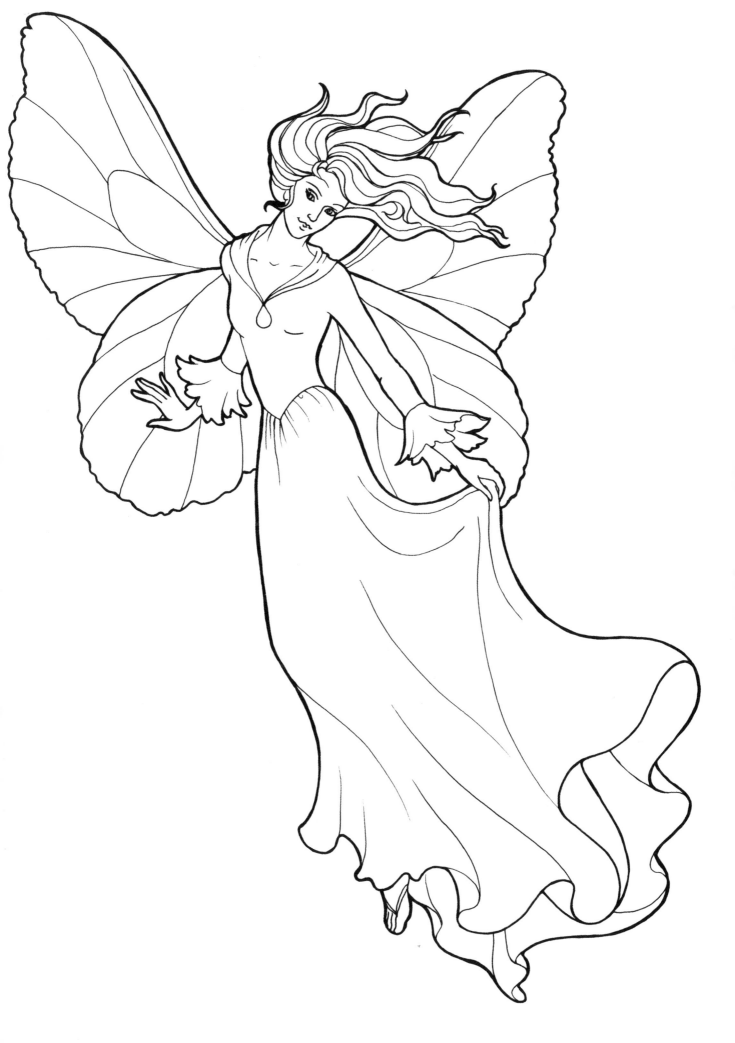

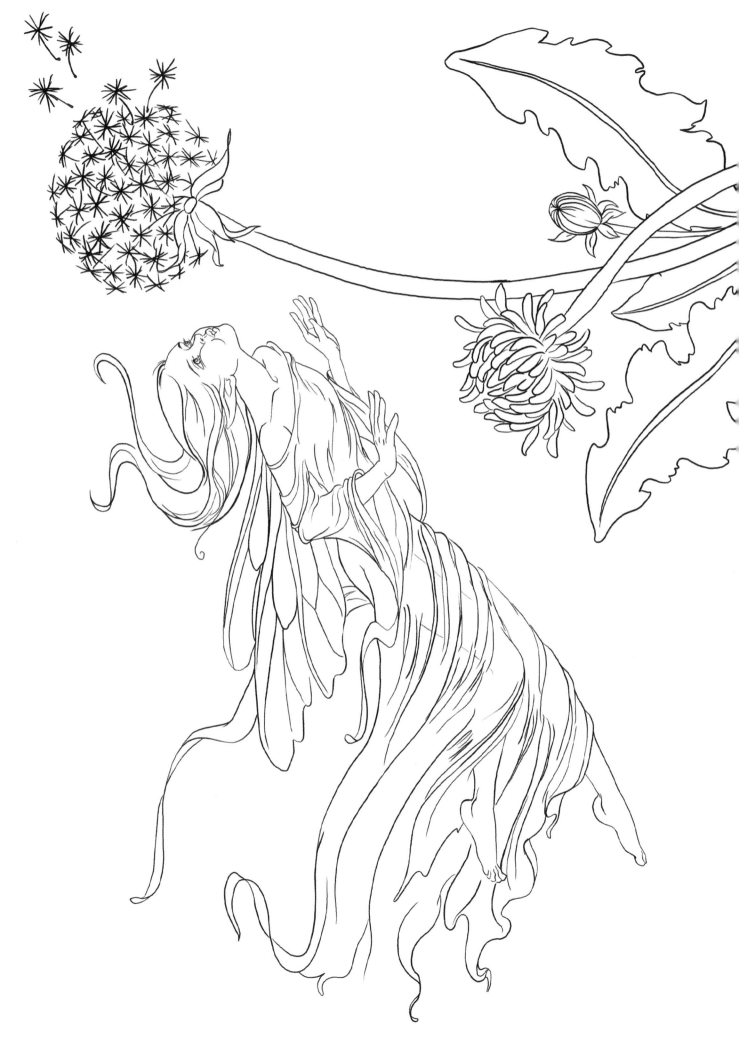

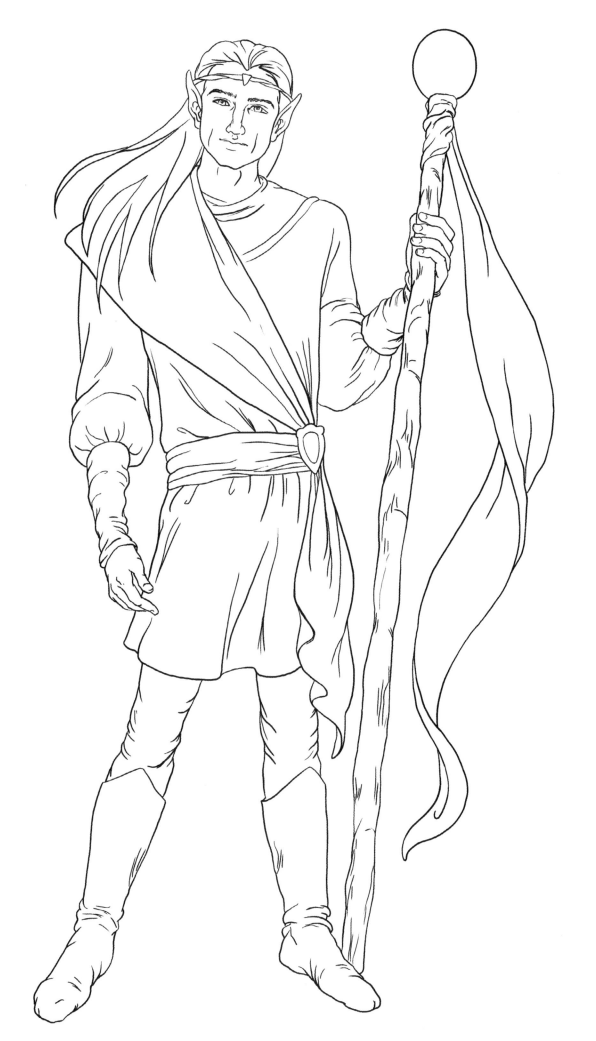

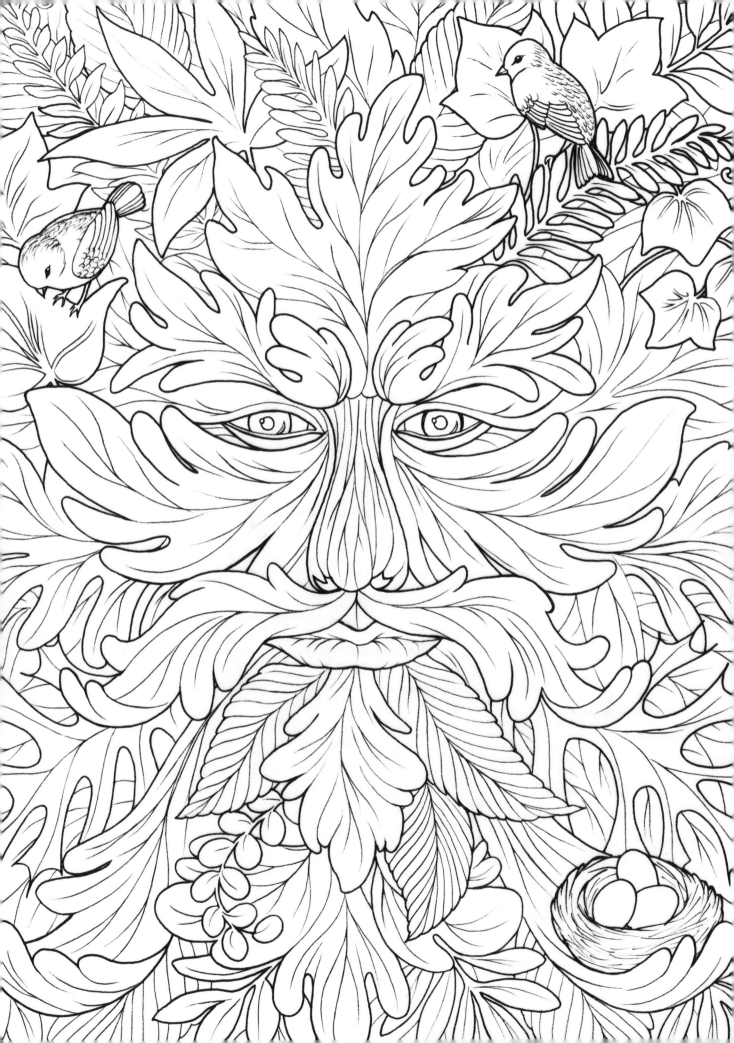

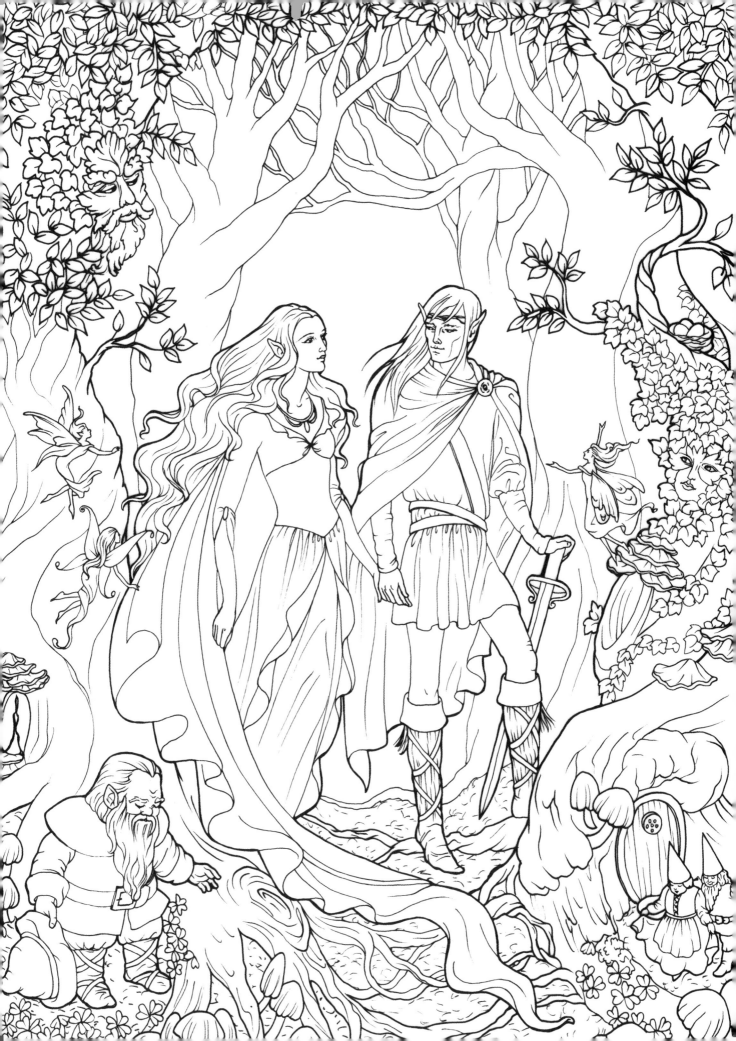

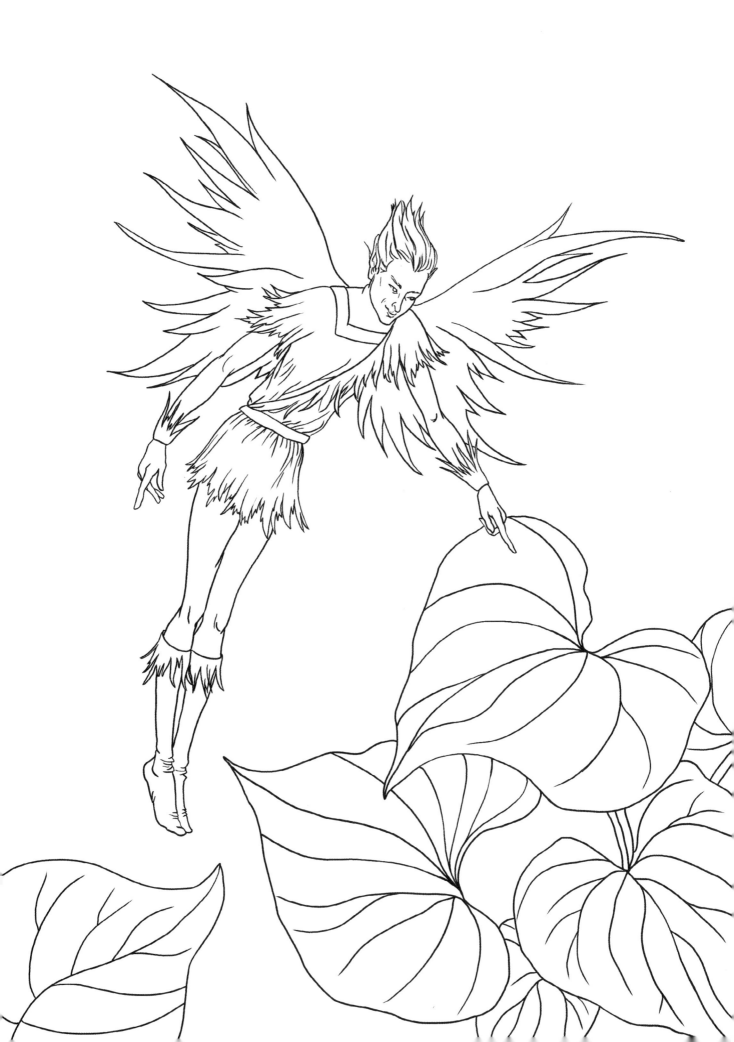

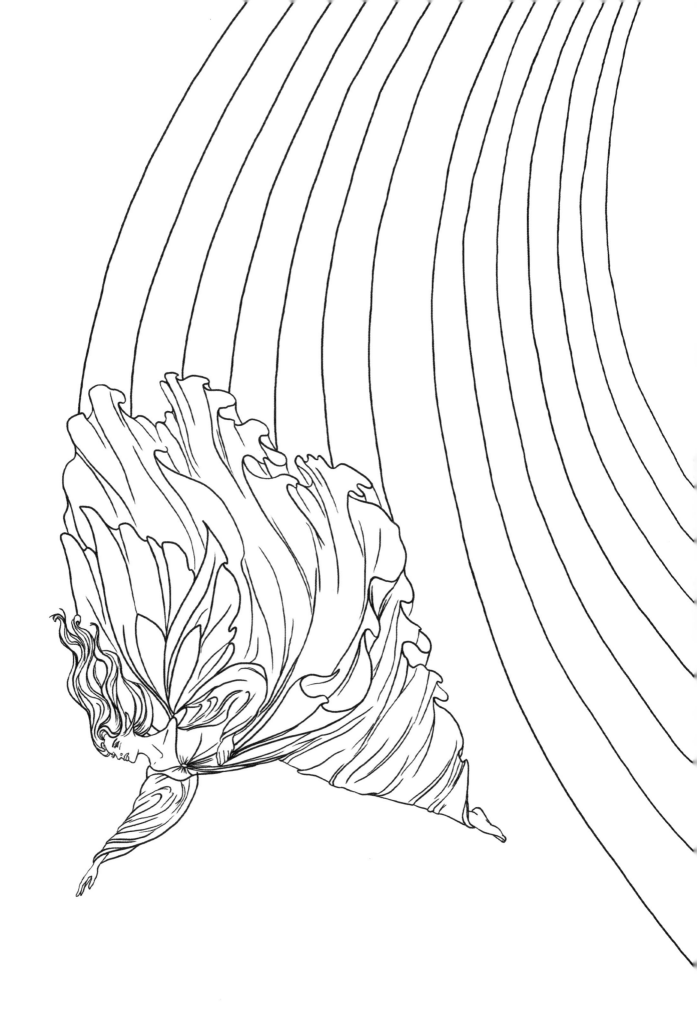

a content + ecommerce company

Other fine North Light Books are available from your favorite bookstore, art supply store or online supplier. Visit our website at fwmedia.com.

20 19 18 17 16 5 4 3 2 1

DISTRIBUTED IN CANADA BY FRASER DIRECT
100 Armstrong Avenue
Georgetown, ON, Canada L7G 5S4
Tel: (905) 877-4411

DISTRIBUTED IN THE U.K. AND EUROPE
BY F&W MEDIA INTERNATIONAL LTD
Brunel House, Forde Close, Newton Abbot,
TQ12 4PU, UK
Tel: (+44) 1626 323200, Fax: (+44) 1626 323319
Email: enquiries@fwmedia.com

DISTRIBUTED IN AUSTRALIA BY CAPRICORN LINK
P.O. Box 704, S. Windsor NSW, 2756 Australia
Tel: (02) 4560-1600; Fax: (02) 4577 5288
Email: books@capricornlink.com.au

ISBN 13: 978-1-4403-4650-7

Edited by Beth Erikson
Designed by Geoff Raker
Production coordinated by Jennifer Bass

About the Author

Barbara Lanza is the author of the successful titles *Enchanting Fairies* and *Enchanting Elves*. After graduating from the Philadelphia College of Art, she became a fashion illustrator in New York City, eventually moved into illustration then collectibles, doll, stationery and textile design. Using graceful drawing and charming imagery, Barbara has illustrated children's books of everyday family life, holiday activities, forest animals and classic fairy tales, including for Little Golden Books, Scholastic/Cartwheel and Viking. Barbara lives with her family in Orange County, New York.